encaustic MIXED MEDIA
INNOVATIVE TECHNIQUES AND SURFACES FOR WORKING WITH WAX

PATRICIA BALDWIN SEGGEBRUCH

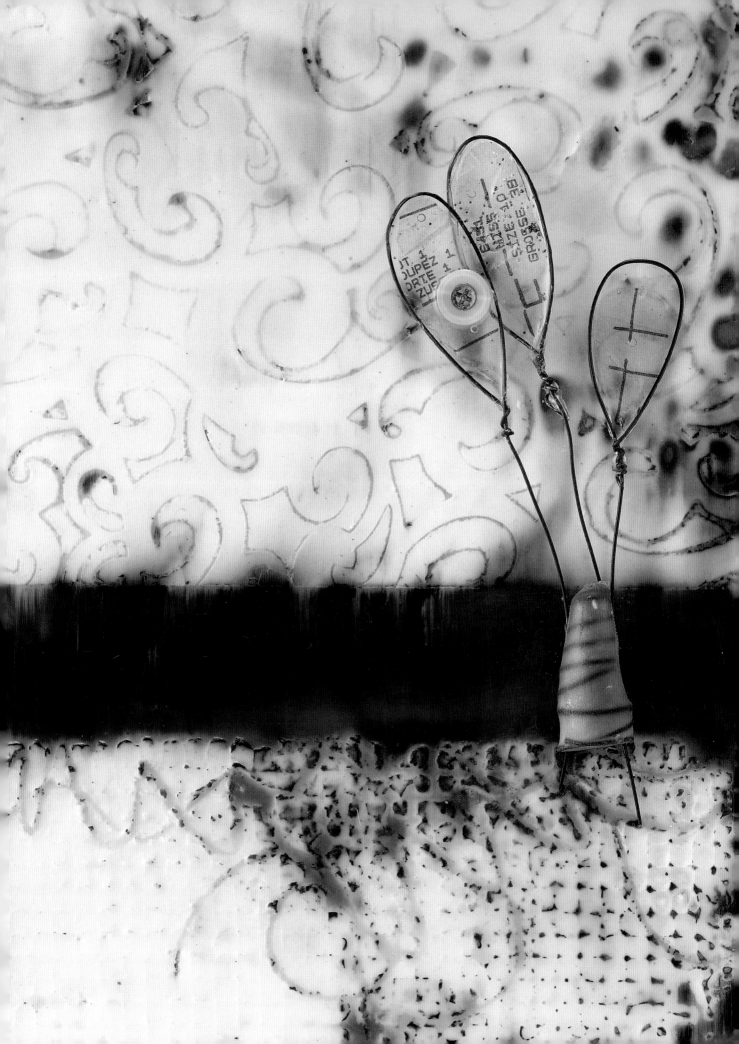

encaustic MIXED MEDIA

INNOVATIVE TECHNIQUES AND SURFACES FOR WORKING WITH WAX

PATRICIA BALDWIN SEGGEBRUCH

NORTH
LIGHT
BOOKS
Cincinnati, Ohio

CREATEMIXEDMEDIA.COM

KITE DAY

www.fwmedia.com

15 14 13 12 11 5 4 3 2 1

DISTRIBUTED IN CANADA BY FRASER DIRECT
100 Armstrong Avenue
Georgetown, ON, Canada L7G 5S4
TEL: (905) 877-4411

DISTRIBUTED IN THE U.K. AND EUROPE BY F&W MEDIA INTERNATIONAL
BRUNEL HOUSE, NEWTON ABBOT, DEVON, TQ12 4PU, ENGLAND
TEL: (+44) 1626 323200, FAX: (+44) 1626 323319
EMAIL: ENQUIRIES@FWMEDIA.COM

DISTRIBUTED IN AUSTRALIA BY CAPRICORN LINK
P.O. Box 704, S. Windsor NSW, 2756 Australia
TEL: (02) 4577-3555

ISBN 10: 1-4403-0870-5
ISBN 13: 978-1-4403-0870-3

Edited by Vanessa Lyman and Kristy Conlin
Designed by Rob Warnick
Cover Designed by Steven Peters
Production Coordinated by Greg Nock
Photography by Christine Polomsky

www.fwmedia.com

METRIC CONVERSION CHART

To convert	to	multiply by
Inches	Centimeters	2.54
Centimeters	Inches	0.4
Feet	Centimeters	30.5
Centimeters	Feet	0.03
Yards	Meters	0.9
Meters	Yards	1.1

ACKNOWLEDGMENTS

It cannot be overlooked, the necessity of a staff behind the production of a publication. A book is not born of a good idea but only conceived. In order to be hatched into the world at large, a team of forward-thinking visionaries is very much necessary!

North Light Books is the force extraordinaire behind the realization of *Encaustic Mixed Media*, in all its glory; I take credit only for the inspiration, artwork and the unedited version of the written word. With greatest thanks and gratitude, this book is born from the exceptional photography of Christine Polomsky, the editorial genius of Vanessa Lyman and Kristy Conlin, the vision of acquisitions editor Tonia Davenport, and the numerous F+W staff members who supported the development of this tome through trust, vision and tolerance to waxy noise and good smelliness wafting throughout the production studio for a week last August!

Much gratitude!

DEDICATION

To the mighty souls who, through God's grace, stand by me, thereby creating in me this authenticity:

To God and John with eternal love. Without one, the other would not be.

To my four redheads. Much bigger, bolder and more independent since the first book dedication, but still in my heart and always my babies.

To Katie, Karon, Kirsten and Christine, the blessed friends who stuck by me, bolstering my confidence when my own sense of self was flagging.

To workshop participants worldwide, because you continue to support the enthusiastic instructors who come to you out of passion and who continue in it because of the love you return to them in spades.

> "If you are determined to gather life, to stick your hand into the hive again and again, to be stung so many times that you become numb to the pain, to persevere and persist till those who know you become unable to think of you as normal, you will not be called mad; you will be called authentic!"
>
> SARAH BAN BREATHNACH

> "The whole is greater than the sum of its parts."
>
> ANONYMOUS

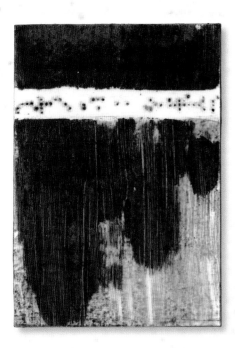
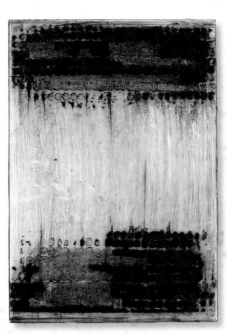
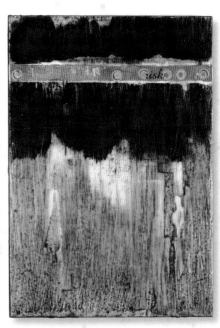

FRATERNAL TRIPLETS

contents

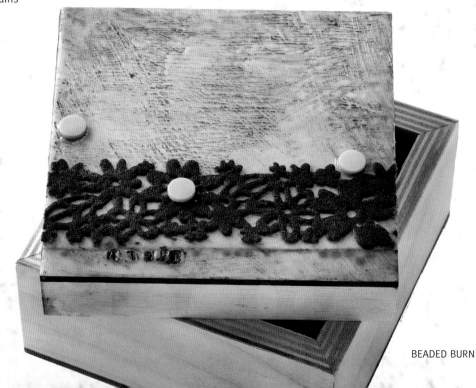

BEADED BURN

sleeve underlap

croisement au dessous de la manche seam line
pestaña interior de la manga ligne de cou
 línea de cos

R

8

introduction

Our souls respond with pleasure to seeing, touching and experiencing beautiful art. To each of us, beauty manifests in different forms; and for each of us, at different times in our lives, the definition of beauty shifts.

Encaustic plays to my sense of beauty in all its manifestations; it makes my soul yearn to have more, see more, touch more. It allows the natural evolution of my sense of beauty to play out in the wax at any stage or time in my growth. Since completing *Encaustic Workshop* and then being graced with an extended period of time in the studio, I've had the good fortune to be able to indulge in the "more" my soul was seeking. *Encaustic Mixed Media* is a result of this more seeking—and finding.

The experimentation I've engaged in over the past year and a half has expanded my view of encaustic's possibilities and enlightened me to a whole new way of thinking about the wax. Abolished are any remnants of "can't, don't or won't work." In their place, I now say, "Wow, how amazing," and "Can you believe how beautiful this is?" Encaustic, I can say with conviction, marries beautifully with everything I put into, on, below, within and alongside it. The possibilities—Oh, the joy!—are endless. You'll never hear me say "no" in encaustic. There is no medium, technique, product, doodad or possibility that I would refuse to try with encaustic!

I didn't begin this way; I followed the rules, doing what was typically and historically done with encaustic. This actually provided me with a vital foundation; to be able to work with and in something, it helps to know what it's "supposed" to do and how it works. I played by the rules for a good year, and then I

started to push—and was amazed at how far the medium could go. I finally came to the same place I'd been with my mixed-media paintings for the past decade: complete abandon and experimentation!

So in this second book, *Encaustic Mixed Media*, I bring you all the trials (leaving out the tribulations) of my indulgent time in the wax. My goal is to highlight the versatility of the wax and the unending possibilities for other media in encaustic painting.

You can use this book in much the same way the first book was designed; treat yourself to each project, one by one, and experience how your encaustic painting can change by trying out all the techniques. Or open to a project that speaks to you and play in it to your heart's content.

With this book, I've just touched the surface of all the possibilities in wax. I know there are more and that each of you delving into this book will find them and expand yet further the opportunities for beeswax to take art to the next level. I encourage you: Delve! Expand! Take everything to the next level—and share with the world. Jump in! And again, as always, I invite you to keep in touch; contact me with questions, illuminations, concerns and joyous breakthroughs. Visit me at www.pbsartist.com or www.gingerfetish. blogspot.com. I welcome and look forward to hearing from everyone.

Blessings!

Trish

> **"The principle goal of education is to create men who are capable of doing new things, not simply of repeating what other generations have done—men who are creative, inventive and discoverers."**
>
> JEAN PIAGET

tools and materials

Often artists shy away from beginning in encaustic because they fear a costly investment to get started or a messy setup that will take over their studios. Neither fear is warranted. The cost can be kept minimal by investing in products from home stores or hardware stores (which work just as well as more specialized products), and the mess is nonexistent. The product is self-contained in its cooled state, and all tools and surfaces can be cleaned by simply melting the wax away. In fact, if you're using brushes and other tools specifically for this medium, they need not be cleaned at all!

You need only a few basic essentials to begin encaustic painting. I've listed them here, along with a few of my favorite tools, to get you started. As you begin to explore the techniques in this book, you will realize that the possibilities for tools and materials compatible with encaustic are endless. Anything goes! Once you master working with the basic elements of the medium, the sky is the limit.

WAX

Refined beeswax is the standard in encaustic painting. It has been treated to remove the natural yellow of the beeswax and it produces a clear, glass-like finish when used with or without damar resin. Refined is a better choice than bleached beeswax because the bleached wax can yellow over time due to the chemical processing it's gone through.

Natural beeswax is a gorgeous choice for rich, organic painting because it is still in its natural, yellow state, and it lends that quality to the finished work.

Damar resin can be added to the beeswax to lend a bit of durability and luminosity to encaustic painting. But this additive is not required, and some artists work strictly in beeswax and still obtain durable, luminous results.

Medium is the name given to the combination of beeswax and damar resin. You can make your own, but pre-made medium is the most advantageous choice for ease of use. This is a combination of refined beeswax and damar resin that has been desig-

nated the optimal combination by the producer. All that is required of you is to melt it down and paint. The choice between refined beeswax, natural beeswax and medium is a personal one, and I encourage you to experiment with each to find your preference.

There are many sources for encaustic wax out there, from your local beekeeper producing natural wax to international companies creating beautiful refined waxes for clear, white application. I encourage you to explore your options, but if you are a beginner, I recommend using refined beeswax or medium from R&F Handmade Paints. R&F has been perfecting its products for decades and is dedicated to producing the best encaustic products for artists. This, combined with the fact that its customer service representatives can answer any questions a beginning encaustic artist may have about product and technique, makes R&F a fabulous resource for all things hot wax.

Here you can see the difference in appearance between natural beeswax, at the top, versus refined clear medium, shown just beneath it.

PALETTE AND TINS

In encaustic work the palette is where the wax is melted, mixed with colored pigment and kept fluid. Any flat surface that can be heated will suffice as a palette, but it is important to have a regulated heat gauge—rather than one with simple low, medium and high settings—in order to control the wax temperature. The palette temperature needs to be around 220°F (104°C) to maintain an optimal melted wax temperature of 180°–220°F (82°–104°C).

Two great palette options are an anodized aluminum palette designed specifically for this purpose or a simple griddle from the small appliance section of any home store. The anodized aluminum palette is great for mixing colors directly on the surface, because it has a clear surface that maintains true color representations in mixing. But this surface does require a separate electric stove element placed underneath the palette to heat it. The griddle is not an advisable surface for directly mixing colors, but it is fairly inexpensive, has a nice, large surface area and heats up evenly and automatically all on its own.

The cleanest and most efficient way to have multiple colors of wax melted at one time is to use tins arranged on the palette to hold different encaustic paints. I prefer 16-ounce (473ml) seamless printmakers' ink cans from Daniel Smith Artists' Materials, but anything similar would also work. I have found these cans to be indispensable in my encaustic setup because they allow for large volumes of wax to be always at the ready and for my brushes to remain upright in their designated cans. You can mix a different color in each one, and if you need just a small amount of a color, you can use the lids to mix limited quantities.

The palette setup described here is wonderful for an easy cleanup; just turn everything off and let it cool down. When beginning again the next day, simply warm the palette; wax melts, brushes loosen and painting can begin again.

This typical palette setup features printmakers' ink cans filled with colored wax and uses an anodized aluminum palette from R&F Handmade Paints; the palette thermometer helps monitor the wax temperature.

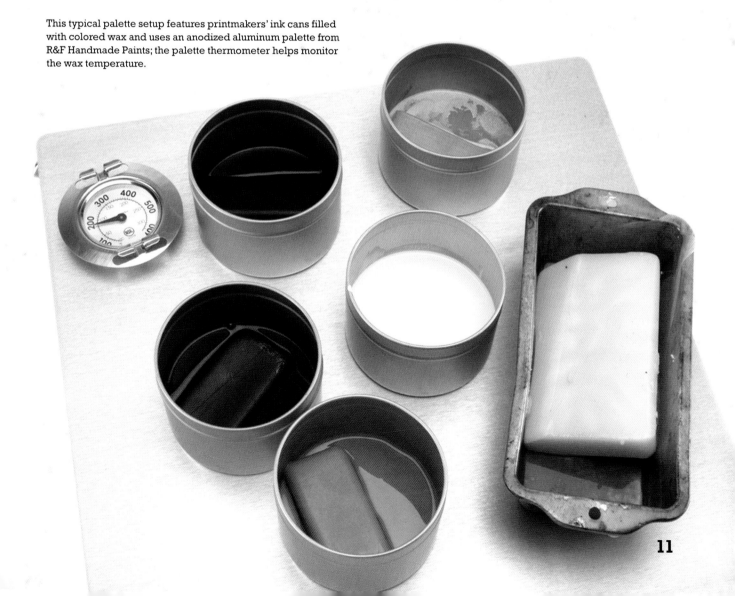

FUSING TOOLS

Fusing is the reheating of each applied layer of wax so it bonds with the preceding layer, thus ensuring a cohesive surface to your encaustic painting. The heat gun is my tool of choice for fusing because it offers control and ease of use. R&F sells a nice one, and others are available from other encaustic sources and hardware stores. I have a preference for the Wagner heat gun. It offers variable temperature control separate from a variable air flow control.

Alternative fusing tools are propane torches, irons and tacking irons. The propane torch offers a strong, concentrated flame and works well for spot fusing, but offers less control for fusing an entire surface. The iron and tacking iron both work well for either spot fusing or surface fusing, but I find I have less control with these tools than with the heat gun because the irons apply the heat directly to the wax. For this reason, they must be set at exactly the right heat setting so as not to melt any of the wax away from the surface.

SURFACES

Two rules here: rigid and absorbent. The surface on which you paint in encaustic must be rigid; it cannot be flexible. Wax cools hard and will chip off a surface that has any give to it, such as paper or canvas. If you enjoy working with these surfaces, you can paint in encaustic on them as long as you first adhere them to a board for support.

The surface also needs to be absorbent. The wax has to have something to grab hold of in order to establish a solid foundation on which to build with more wax and additional elements.

My favorite foundation for encaustic painting is Ampersand's Encausticbord. This surface is a luscious, luminous white, a result of the partnering of R&F Paints with Ampersand (R&F's encaustic gesso applied via Ampersand's surfacing process). This board, developed and released after years of wanting for it in the encaustic world, is a welcome addition to the many surfaces available on which to paint. It is my go-to surface, not only for the rich absorbency and compatibility with encaustic, but also for the variety of sizes and options for cradling; found in 1" (3cm) and 2" (5cm) cradles, Encausticbords offer a rich, contemporary look on which to create encaustic paintings.

Many unprimed wood art panels are readily available from art supply stores as well; one of my favorites is Elephant Board. And even a trip to the hardware store can offer the power-tool-friendly artist options in wood surfaces that can be cut and transformed into surfaces for encaustic work.

When the wax is completely melted on the typical palette setup, simply assign a natural bristle brush to each color for easy painting and hassle-free cleanup.

BRUSHES

One rule: Go natural. Synthetic brushes will melt in hot wax. My favorites, both from Daniel Smith Artists' Materials, are hog bristle brushes in assorted sizes and hake brushes (also known as sumi painting brushes). Avoid using brushes with nailed, metal handles because the heating and cooling of the wax can loosen the nails and causes the bristles to fall out. Brushes ranging in size from 1"–3" (3cm–8cm) work well for all the techniques shown in this book.

OTHER TOOLS

I enjoy experimenting with anything that I think could have an interesting effect on the wax. For incising—cutting design elements into the wax—I turn to pottery tools, awls, styluses, cookie cutters, putty knives and metal and wood filing tools. From the scrapbooking stores, I collect stamps, interesting stickers, embellishments and rub-ons. My favorite burnishing tool is a simple spoon, but bone folders and scissor handles work well, too. Other tools I have readily available for use in my encaustic studio are a metal ruler for straight-line incising, a small propane torch, assorted screens and stencils for incising, and extension cords to allow for maximum reach with my heat gun.

MIXED MEDIA

Art supply and craft stores are great places to collect interesting collage papers, foils, leafing, oil paints, pastels, charcoals and photo transfer papers for use with the various encaustic techniques you will learn in this book. Likewise, scrapbooking stores offer a nice selection of rub-ons, papers, items to embed in your work and even unique incising tools.

I also scour hardware stores, fabric stores, salvage yards, thrift shops and garage sales for interesting materials to use in my encaustic work. Look for one-of-a-kind items to embed, from vintage buttons to rusty coils. You may even be surprised by the treasures found lingering in your junk drawer.

Leave no stone unturned in your search for innovative materials to use in your encaustic work. I can't begin to list them all, and I'm willing to bet that once you get started, you will find some I have yet to discover.

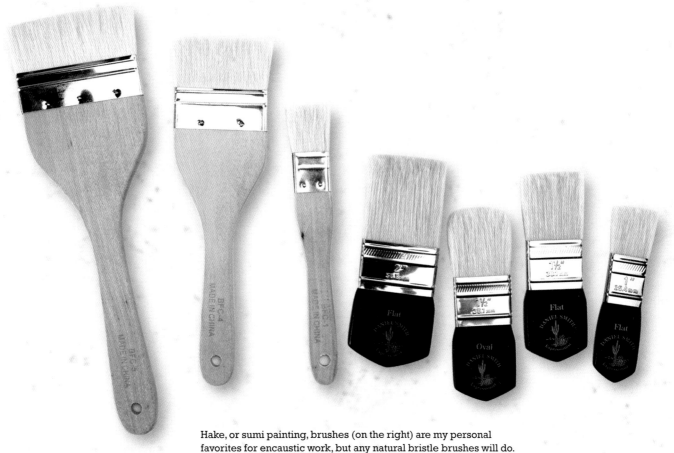

Hake, or sumi painting, brushes (on the right) are my personal favorites for encaustic work, but any natural bristle brushes will do.

creating colored wax

There are three main types of color you can add to wax for encaustic painting: pigmented medium, dry pigment additive and oil paint additive. All can be beautiful mediums for achieving colorful encaustic artwork.

PIGMENTED MEDIUM

This is my steadfast favorite option. Not only is it the easiest, neatest and safest, but the array of color options and consistency of color are an easy sell. These pre-made colors are sold through many encaustic producers, but I use R&F Handmade Paints in illustrating the techniques throughout this book. These encaustic paints come in rectangular blocks that fit nicely into the large printmakers' ink cans from Daniel Smith Artists' Materials that I use for quick melting.

Encaustic manufacturers have machines that produce a beautiful color in the wax by milling the colors to a very fine consistency. Pigment suspension in the wax is optimal with these products. And their intensity can be varied simply by adding medium.

DRY PIGMENT ADDITIVE

You can also make your own colored wax by adding dry pigments to medium to create customized colors. This method should be used with caution, because it involves working with loose particles that can be very dangerous to inhale. Also, getting a consistent color throughout a batch—or re-creating a color exactly as you created it before—can be difficult. I try to stay away from this technique because I favor the consistent hue and ease of use of the ready-made pigmented medium, but many artists find mixing their own encaustic paints to be highly satisfying.

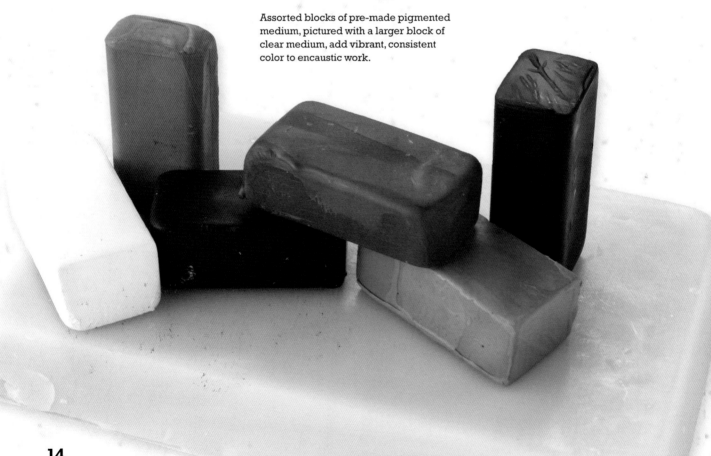

Assorted blocks of pre-made pigmented medium, pictured with a larger block of clear medium, add vibrant, consistent color to encaustic work.

OIL PAINT ADDITIVE

A third choice for coloring wax is to add oil paints or oil paint sticks to the medium. This, too, can be effective and enjoyable if you like to create your own colors. I have found that oil paint sticks work better than traditional oil paints because the greater oil content in the traditional paints can dilute the medium, but you can use either successfully if you follow the steps below.

PREPARE OIL PAINT OVERNIGHT
Squeeze oil paint onto a paper towel and let it sit overnight so the excess oil leaches from the pigment. This will allow the pigment to blend more easily into the medium.

ADD PAINT TO MELTED MEDIUM
Add a bit of the paint directly to some hot wax medium. Experiment with the concentration, being conservative at first and gradually adding more, to achieve the desired color intensity.

OPT FOR OIL STICKS
The oil content of pigment sticks is much less than that of traditional oil paints, so they can be added directly to the medium without the paper towel leaching process in step 1, above. Simply cut them directly into the hot wax medium. Here, I am using an R&F Handmade Paints oil stick.

ENCAUSTIC PAINT

The paints I choose to use and teach with are from R&F Handmade Paints. These highly pigmented, wonderfully lush paints have been manufactured to be the best possible for the encaustic artist. The color selection and depth of pigmentation just can't be beat! They can be used straight up in their full concentration or diluted with encaustic medium to extend the product and to offer a bit more translucency. If one wishes to, encaustic paints can be made by adding oil paint, pigment sticks or dry pigments to encaustic medium. Although these methods of paint creation are quite viable, I continue to return to R&F's products because of their quality and consistency. Many other manufacturers have entered the encaustic paint-making arena in the past few years, and I encourage you to explore the options and find the products that best suit your personal creative direction.

priming and fusing

Pick up your brush and begin! Grab your beeswax and come join me! Yes, it's that easy. Encaustic is just another paint medium, ready to be manipulated by the creative spirit within each person who has the dream to watch it flow.

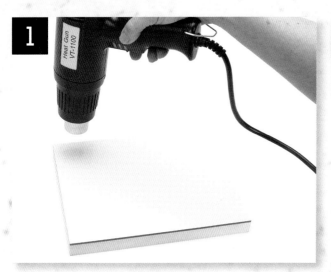

Many of the projects in this book begin with a prime layer of medium. To accomplish this, warm the board with the heat gun. Hold the gun perpendicular to the surface, about 2" (5cm) away, and slowly sweep the heat back and forth across the board from top to bottom. The objective is to achieve a consistently warm-to-the-touch surface (about 30 seconds).

NOTE: Keep the gun moving or you risk creating a hot spot that will resist the application of wax.

Using a large, flat brush, apply a sweep of wax across the board, covering the whole surface in this way until an even layer of wax exists.

NOTE: Avoid overlapping strokes so that fusing will result in a smoother, more consistent layer.

NOTE: Returning the brush to the hot wax after each stroke will create a smoother application and help the brush move more easily since the wax remains warm and fluid.

> **"The best way to make your dreams come true is to wake up."**
> PAUL VALERY

WHAT YOU'LL NEED

Encausticbord, claybord or wood panel

Heat gun or fusing tool of choice

Melted beeswax or medium

Wide paintbrush (2" [5cm]; hake recommended)

Needle tool (optional)

Using the heat gun, fuse this prime layer of wax by again sweeping the gun back and forth over the layer of wax in slow, even strokes.

NOTE: When the wax transforms from a dull matte finish to a shiny gloss, it has fused. It is not necessary to melt the wax completely to achieve a fuse; achieving this gloss is sufficient.

If any areas are unwaxed after the first application, simply apply additional wax to those areas and re-fuse them with the heat gun.

If you see any stray hairs or particles in the wax, gently pick them out with a needle tool. Reheat to smooth the disturbed wax.

BRUSH UP

This same technique of wax application may be continued with additional medium to build up a thick foundation, or you may move to the application of pigmented encaustic paints at this point. Once this base of priming has been established, any technique can begin. You are ready to try your hand at encaustic painting, collage and indulgent experimentation!

This prime layer is not mandatory to paint in encaustic. It is only a helpful suggestion so that once you begin in color, your more expensive, pigmented paints do not disappear into the board because of the sheer absorbency of the unprimed surface. Many of the techniques in this book begin with foundations on the surface before any wax is used. Therefore, this priming technique is put into play once these foundations have been established.

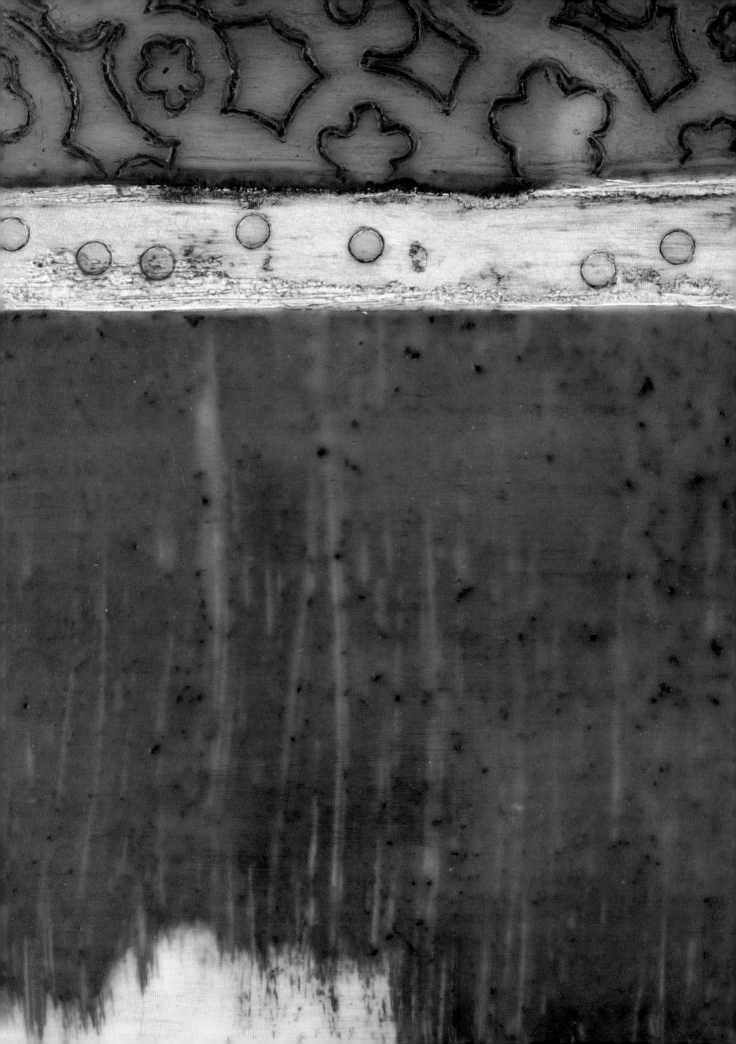

the projects

acrylic paint

I ordinarily do not support falling into temptation. But when it comes in the form of art, creativity and artistic creation, I embrace it fully in the "anti-law" of "no no's!"

Acrylic and encaustic are not thought to play well together; the two just don't have enough in common to stay together for any length of time. Although many artists have worked their way around this mismatched duo and found a way to keep them together, I've never wandered into that camp. Yet I did try it recently, and I discovered such wonderful success that I have to spread the word.

How does one go from "never go there" to "look what I did!"? Well, what happens when you need that "just right" color but can't find it among your stash? You search every wax tin, go through your travel stash and even check the palette's drip pans to no avail. I had this problem and, in a frustrated huff, glanced toward my GOLDEN Fluid Acrylics stacks. The bold and beautiful Quinacridone Magenta nearly leapt off the shelf and onto my painting! It glowed red hot with a "Choose me!" siren song. I couldn't resist and reasoned that I could always remove it if it was a disastrous marriage. So I went at it with a determined vengeance, and guess what? I've not turned back. I found myself venturing into other paintings, other surfaces and other applications for acrylic in my encaustic. I'm hooked! I hope to cast my convincing line your way and hook you as well.

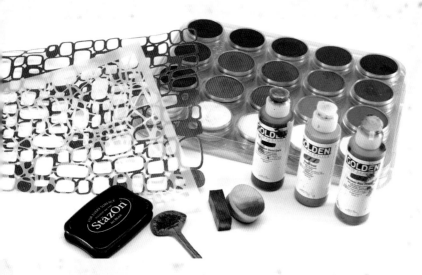

TOOLS OF THE TRADE
PanPastels, GOLDEN Fluid Acrylics, Mary Beth Shaw stencils to die for, StazOn ink, and Stamping Bella stamps. All used to create the fun in acrylic and encaustic!

WHAT YOU'LL NEED
- Encausticbord
- Acrylic paints
- Rubber stamps
- Masking tape
- Encaustic medium
- Paintbrush
- Heat gun
- Stencil
- PanPastels
- Sponge applicator for pastels

> **"The only way to resist temptation is to yield to it."**
> OSCAR WILDE

RACHEL'S GARDEN

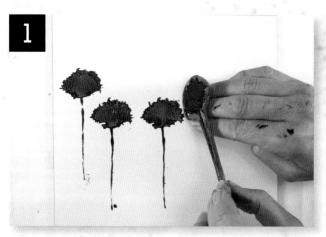

Apply acrylic paint to the rubber stamp and apply the stamp to the Encausticbord. Set aside to dry completely.

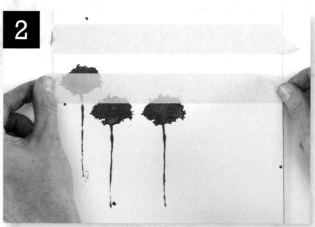

Apply masking tape to the board. Here, I've chosen to apply two strips of tape across the top third of the piece.

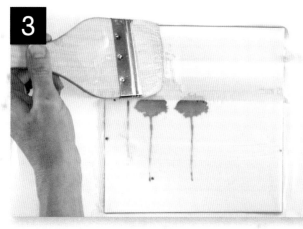

Warm the board with the heat gun and apply a layer of medium. Fuse this layer; allow to cool. You will repeat this step as you add multiple layers of wax.

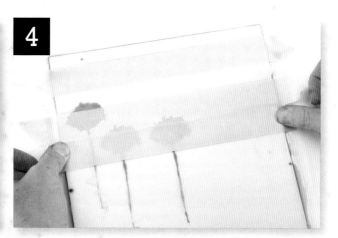

Apply a third strip of masking tape. I'm masking off different areas to produce different depths of wax, which will become obvious once the piece is painted and the masking is removed.

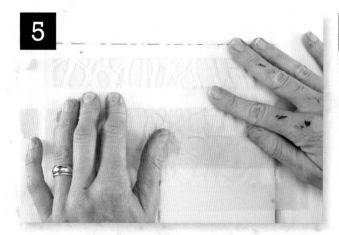

Press the stencil into the still-warm wax.

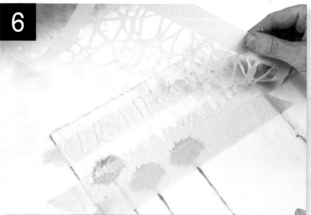

Apply several layers of wax over the stencil to build the dimension of wax around the design. While the wax is still warm, remove the stencil.

7

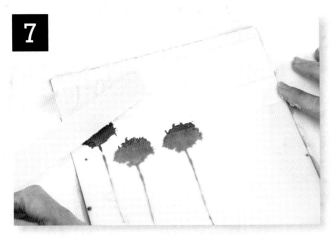

Continue to reveal the waxen dimension by removing the masking tape while the wax is still warm. This will ensure crisp, sharp lines. Set aside to cool.

8

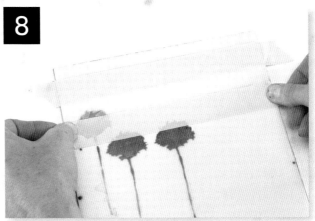

Apply new tape strips, adhering them to the same areas as in step 2.

9

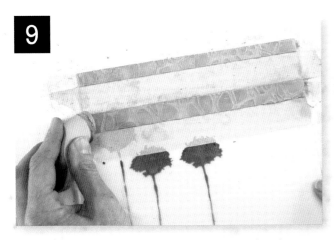

Using the applicator sponge, apply the PanPastel to the surface of the piece, across the stenciled area. Here I've chosen to apply it to the raised top third of the piece only.

10

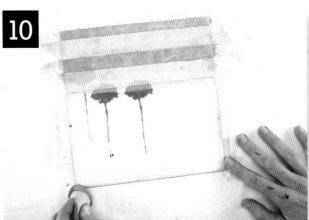

Continue applying the PanPastel along the edges to "blush" the frame around the piece.

11

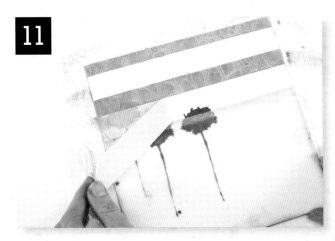

Remove the masking tape.

12

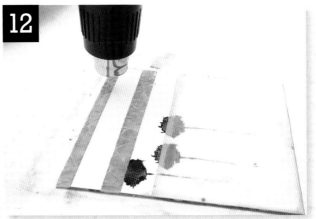

Fuse the pastel to the wax with the heat gun and allow the piece to cool completely.

flocking

Drilling into a beautifully composed encaustic painting may seem like risky business; why would you want to risk losing the beauty of a completed piece for a potentially interesting, yet not assured, added dimension?

Because the reward of this added dimension is just too luscious and desirable to pass up, that's why! And we are experimenting after all, right?

So I move forward to share some extra-exciting fun: the use of resin, flocked paper, power tools and even panty hose with encaustic. So delicious. Come with me as we loosely combine techniques commonly found in jewelry design, carpentry and scrapbooking with our main love, beeswax. It's a risky business, but that makes it all the more fun!

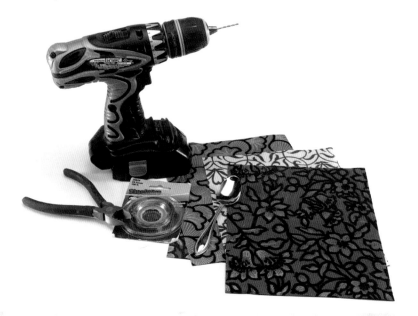

WHAT YOU'LL NEED

Wood panel

Heat gun

Encaustic medium

Paintbrush

Flocked paper

Burnisher (spoon or craft stick)

Drill

Wire

Wire cutters

Resin embellishment (see page 110 for mini demo)

Panty hose and glue embellishment (see page 111 for mini demo)

TOOLS OF THE TRADE
The "fluff" of flocked paper is used alongside power tool drilling and wiring to give this painting a feminine as well as masculine interpretation.

"The greatest mistake you can make in life is to be continually fearing you will make one."
ELBERT HUBBARD

LEATHER AND LACE

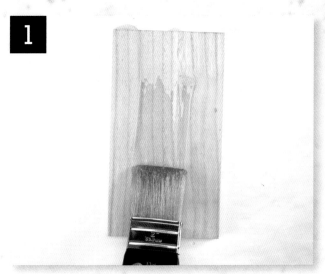

Use a heat gun to warm the wood panel and then apply medium.

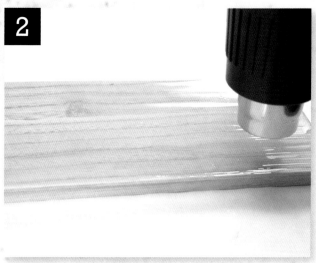

Fuse the medium to the board using the heat gun.

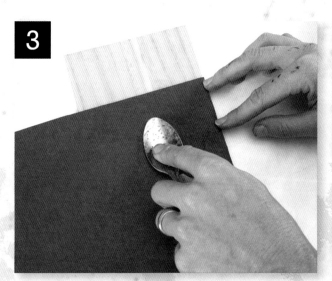

Place slightly warm flocked paper facedown over the bottom portion of the waxed board. Rub the back of the paper with the burnisher.

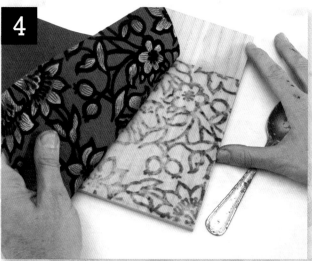

Peel away the paper; the flocking will have transferred from the paper to the wax.

5

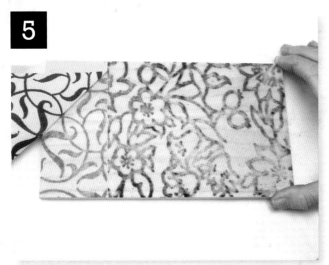

Apply a second piece of flocked paper to the top section of the waxed board and repeat steps 3 and 4.

6

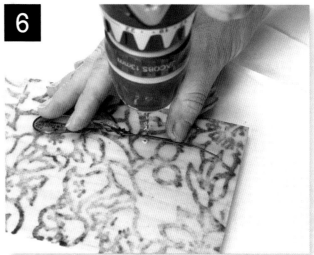

Drill two holes in the board where you will be placing your resin embellishments. (You can leave them on the board for reference.)

7

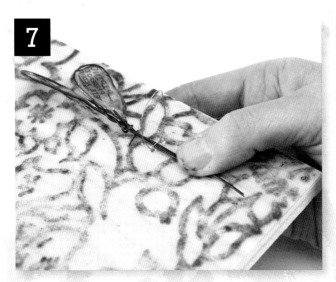

Thread the wire through the holes, and then twist the wire together on the back side of the board to secure the embellishments to the board.

8

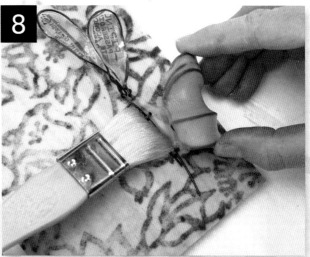

Dab a little wax on the surface of the board where the panty hose and glue embellishment will go, and adhere the embellishment to the board.

wood glue

I touched on Elmer's glue in my first book, *Encaustic Workshop*, but I have made wild new discoveries since then. The surface texture and visual interest this product lends to wax painting compares to nothing else I've seen. I went beyond for *Encaustic Mixed Media* by bringing wood glue into play, as well as some serious torch work. These two together play into my love of the amber just as shellac has done (and continues to do).

Burning this glue produces a rich, tawny-to-black glow. Stopping early in the process, burning for an extended period or maintaining the glue-flame connection until the glue has completely dried will each result in varying degrees of color. I rarely stop at the first hit of the torch, and I encourage you to do the same. Explore further into a full burn before settling into your favorite point in the color range.

Employing encaustic medium in layers, masking off, scraping back and building texture pull this alternative foundation technique together, resulting in a rich, organic, dirty wax painting.

Jump in and let's get burning!

WHAT YOU'LL NEED

Wood panel

Masking tape

Wood or white glue (Elmer's)

Fire-retardant surface

Propane or butane torch

Encaustic medium

Paintbrush

Heat gun

Embossed wood paper embellishment (see page 107 for mini demo)

Razor blade

"Creative minds are rarely tidy."
ANONYMOUS

TOOLS OF THE TRADE
Torch, glue, wood—a great combination! Embossed wood paper adds even more visual impact to this heavily burned wood-glue piece.

AMBERGLOW

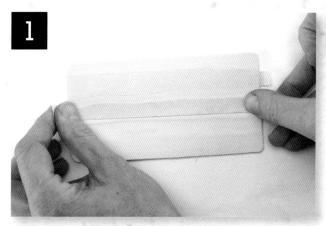

Apply masking tape to the wood panel so as to preserve a portion of the natural wood to burn later.

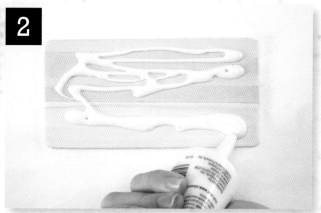

Apply wood glue to the panel's surface.

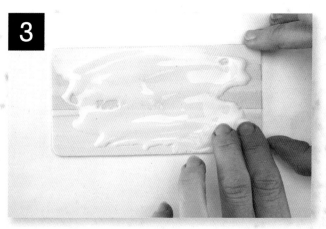

Smear the glue evenly over the surface.

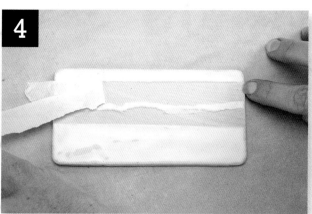

Remove the masking tape. The glue should hold its shape.

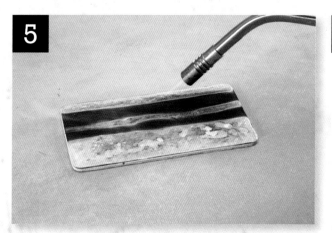

Place the wood panel on a fire-retardant surface, and use the torch to burn both the surface of the board and the glue. Allow the wood panel to dry thoroughly before moving onto encaustic.

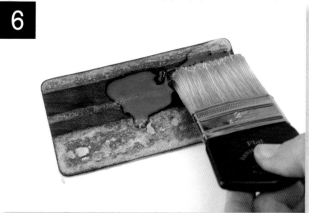

If you have interesting areas of dimension caused by the burn—as I do here—dripping medium over that area rather than brushing it on can help preserve it. Once you have preserved any interesting dimensional areas, apply medium over the entire surface of the panel.

7

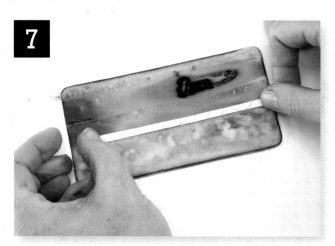

Apply a strip of embossed wood paper.

8

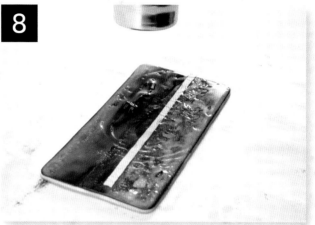

Run the heat gun over the surface to fuse the layers.

9

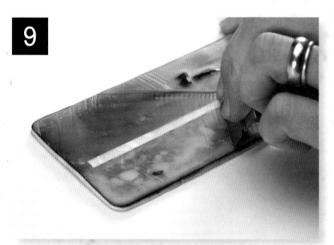

Apply layers of medium until you have achieved the desired effect. Using a razor blade, carefully scrape off any excess wax, particularly around any dimensional areas where you may have dripped the wax.

10

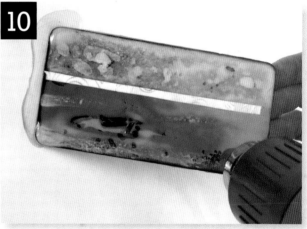

You can also melt the wax around the dimensional areas to thin it and soften any razor strokes.

NOTE: Wax will pass through several stages of transparency. While fluid, it will be transparent, then become cloudy when warm, and then return to more transparency when it's dry again. If it's really thickly applied, it will be less transparent simply because of the depth of the wax.

shellac

Shellac may be my very favorite addition to encaustic painting. It began with a very controlled, safe burn of the dried shellac on wax and has evolved into an all-out extreme indulgence of everything amber-rich and fired up—like what you see here!

Shellac strikes encaustic purists as an odd partner for wax. As a sealant or finish, shellac is completely unnecessary; encaustic is its own final finish. But putting aside its messiness and caustic state, shellac blends beautifully in the wax.

Why caustic? We are setting it aflame! Do this only in the open air (I use my driveway on a rain-free day), and never lean over the surface as you watch it burn—unless you hate your hairstyle!

You can go beyond the amber shellac if you do not have the same affinity for it that I do. Use clear shellac instead, but before taking any steps, color it as you desire with dry pigments, Pearl Ex Powdered Pigments or even dry pastel scrapings. The result will be your own custom-colored shellac.

WHAT YOU'LL NEED

- Claybord
- Encaustic medium
- Paintbrush
- Heat gun
- Alcohol inks
- Shellac
- Paper towels
- Fire-retardant surface
- Propane or butane torch
- Masking tape
- Gesso
- Razor blade
- Encaustic paint: Sap Green

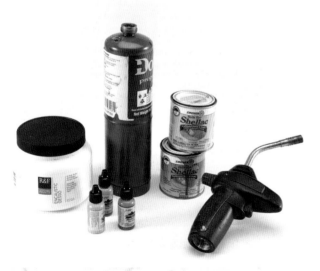

TOOLS OF THE TRADE
Yes, we're getting creative with a propane torch, shellac, ink and gesso!

> **"Imagination is the beginning of creation. You imagine what you desire, you will what you imagine and at last you create what you will."**
> GEORGE BERNARD SHAW

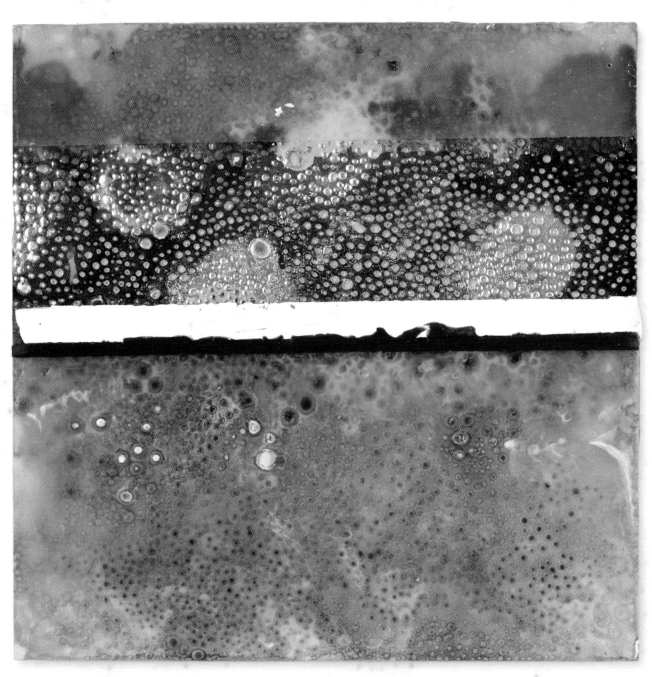

SHELLACITY

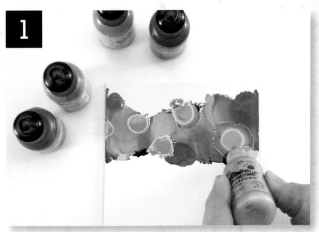

Apply alcohol inks to the surface of the claybord and let dry.

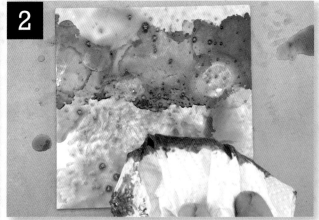

Apply shellac to the surface of the claybord using a paper towel.

BRUSH UP

I choose to use paper towels rather than a brush so there is no solvent cleanup required.

Pouncing the shellac onto the surface yields a thicker application than wiping the shellac onto the surface.

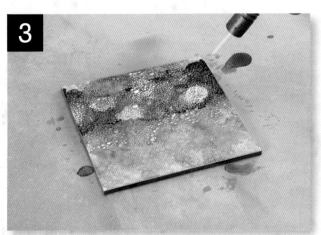

Place the board on a fire-retardant surface. Then, using the torch, immediately burn the shellac, lighting it on fire while it is still wet. Then allow the board to cool and dry. The combination of ink and shellac in this burning technique causes neat effects on claybord: It bubbles up through the inks.

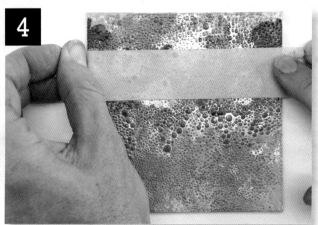

Apply masking tape over the bubbled alcohol-inked area to leave this portion free of encaustic.

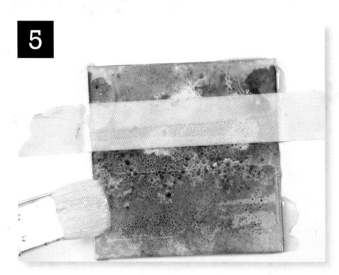

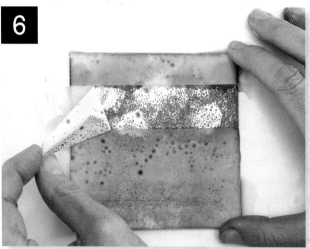

Heat the surface of the board with the heat gun and apply a layer of encaustic medium.

While the board is still warm, remove the masking tape.

WHAT YOU'LL NEED
Lighter

Encaustic paint: Indian Yellow

alternate approach

An alternate approach to steps 2 and 3 is to apply shellac over encaustic. Here I applied it over encaustic paint.

Apply a layer of encaustic paint (here, Indian Yellow) and use a heat gun to fuse the paint to the surface.

Apply shellac to the surface with a paper towel.

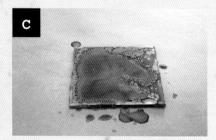

Light the shellac on fire. The fire will burn out as soon as the alcohol burns off. The melting wax below will shift and pool, leaving behind an organic design. This piece will likely take longer to dry, usually overnight.

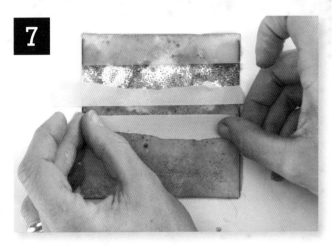

7

Mask off another area on the board to leave it with a lesser depth of encaustic, thus creating differing dimensional layers in the composition.

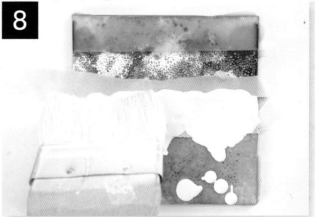

8

Apply gesso between the pieces of masking tape. Fuse once applied.

BRUSH UP

An alternative to applying gesso is to apply encaustic paint between the masked areas. This results in a more flat, opaque strip that contrasts well with the luminous encaustic medium.

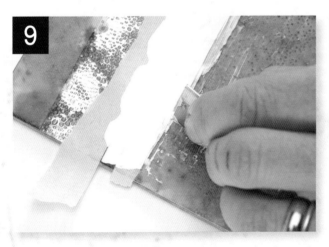

9

Scrape off the excess wax with a razor blade as needed.

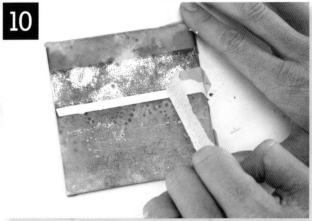

10

Peel up the masking tape. (The wax should still be warm.)

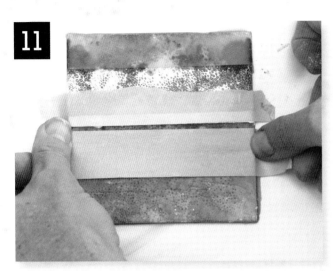

11 Apply masking tape to another area of the board.

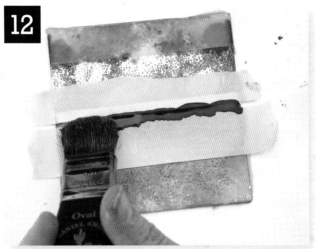

12 Apply a layer of encaustic paint (here, Sap Green) to the board, within the area taped off. Fuse once applied.

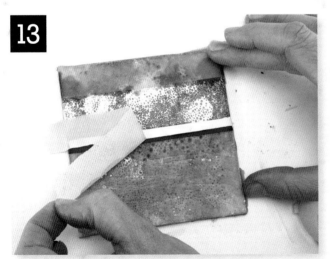

13 Peel up the masking tape while the wax is still warm and scrape off any excess wax with a razor blade.

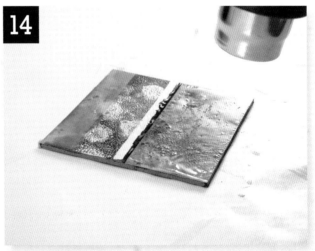

14 Heat the claybord with the heat gun to smooth out any rough edges or brush marks, if you desire.

celluclay

Celluclay has been in the craft world for decades, going through a number of name changes and design alterations. It is a clay-like product of which the base material is paper pulp. It renders easily-shaped 3-D creations that are lighter in weight, more malleable and easier to work with than traditional clays. Celluclay can also be tinted with paint or ink. Simply add a few drops of ink, dye or acrylic paint when mixing to the desired consistency. I love it because it's paper (one of my favorite things on earth!), and it can adhere to (and in) encaustic for an added degree of dimensionality in your pieces.

This dimension allows me, a timid-at-best 3-D experimenter, to take my paintings to a whole new level. I shy away from 3-D simply because my eye has never seen this way. Yet, when given a clear, bright white piece of watercolor paper, claybord or Encausticbord, my nerves tingle at the possibilities!

To be able to enter the 3-D arena and still remain comfortably ensconced in my 2-D world is a thrill. I can manipulate the aforementioned nerve-tingling surface with celluclay, rendering a hint at 3-D, returning with encaustic painting to maintain my desired 2-D. It's blissful to stand on both sides of the dimensional fence!

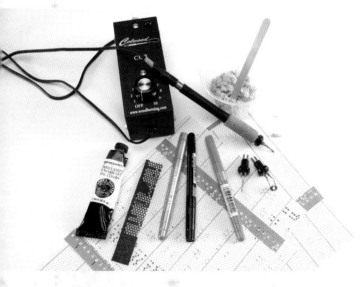

TOOLS OF THE TRADE
My current favorite new find comes into play here: a wood-burning tool purchased from a decoy design website. And do you know about Wholey Paper? Oh my . . .

"The prize is in the process."
BARON BAPTISTE

WHAT YOU'LL NEED

- Cradled Encausticbord
- Encaustic medium
- Paintbrush
- Heat gun
- Stencil (or here, 1" x 1" [3cm x 3cm] claybord squares)
- Wood-burning tool and tips
- Masking tape
- Water-based pigmented marker
- Celluclay
- Disposable cup
- Craft stick
- Pieces of rusted Wholey Paper (see page 105 for mini demo)
- Oil paint: Daniel Smith Iridescent Scarab Red
- Rubber gloves
- Paper towels

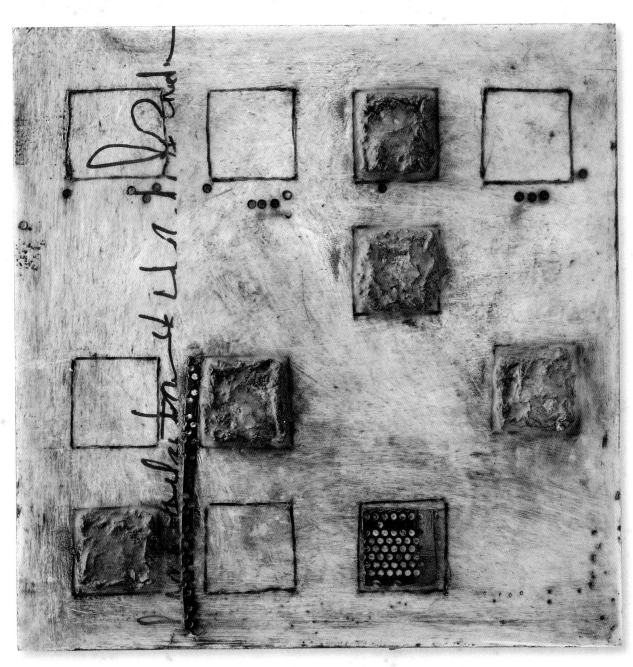

PERIODIC TABLE

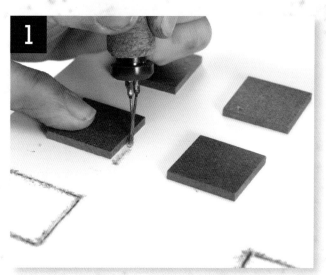

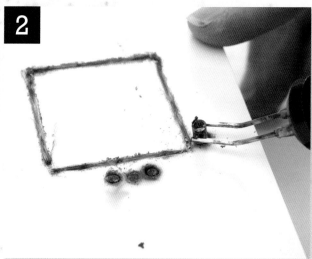

Burn your design into the Encausticbord with a wood-burning tool. I used 1" × 1" (3cm x 3cm) claybords as templates (back side up), burning around the edges with the feathering tip of the wood-burning tool.

Apply a second design with the wood-burning tool for additional appeal. Switch tips—remove the feathering tip and install a circle tip—and burn the design into the surface.

NOTE: Don't brush off the ash, but rather knock the edge of the board against a trash can to remove any ash.

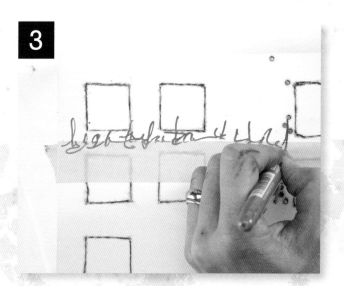

For added appeal, apply masking tape to the surface of the board for purposes of alignment and write or draw a design across the surface using a marker. Remove the tape.

BRUSH UP

I love the consistency of celluclay— it's malleable enough to push into any shape, but it will hold its form. It will shrink a little as it dries, which is an effect to be aware of—though I like how it pulls away from the burned outlines.

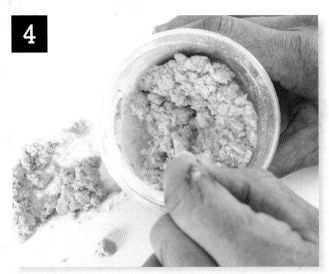

4

Mix celluclay in a disposable cup according to the package's directions.

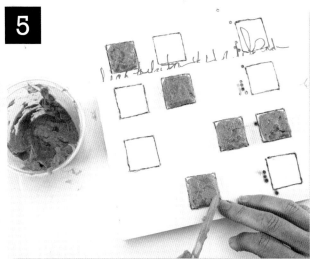

5

Lump the celluclay onto the surface of the board where desired, and use your fingers and a craft stick to shape it. Set the board aside and allow it to dry.

> **NOTE:** The thicker you apply the celluclay, the longer it takes to dry. I set this piece aside to dry overnight.

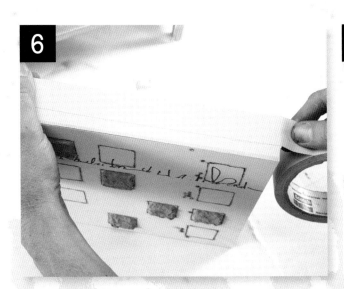

6

Use masking tape to protect the edges of the cradled board, which will be finished later.

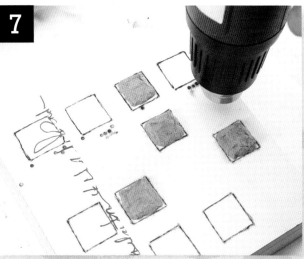

7

Warm the board with a heat gun.

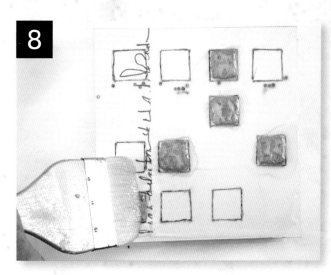

Apply a layer of encaustic medium.

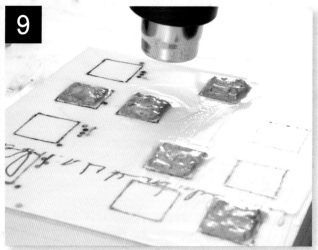

Fuse the wax to the surface using a heat gun.

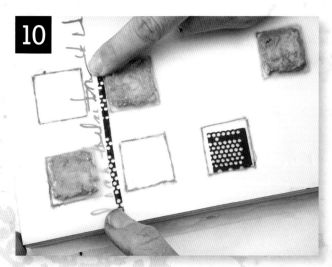

While the wax is still fluid, place pieces of rusted Wholey Paper as desired.

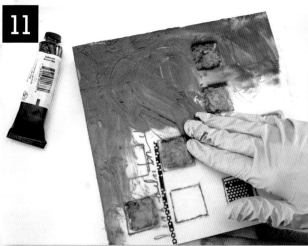

Apply oil paint over the entire surface of the board with gloved fingers. This will tint the wax or "glaze" it with color.

NOTE: Pigment sticks and tubed oil paints are nearly identical in effect. I generally prefer the sticks. If I find a perfect color in tube form—like I did here—then I go for it!

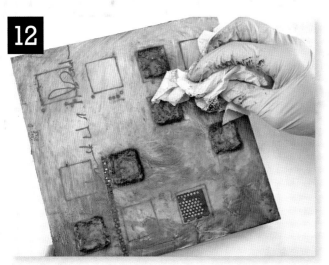

Use a paper towel to thoroughly rub the color into the wax, as well as to remove excess oil paint.

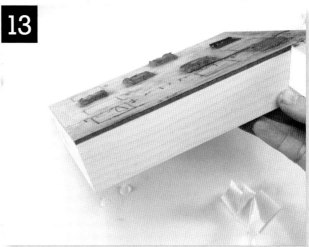

Remove the masking tape from the edges of the cradled board.

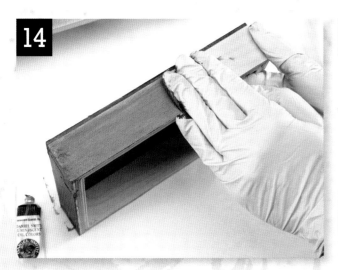

Apply oil paint to the sides of the cradled board to "stain" the wood.

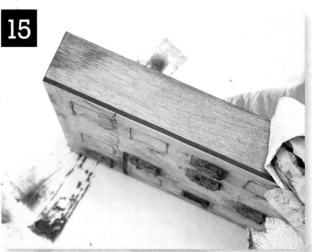

Use a paper towel to rub the color into the wood and to remove excess paint. Set the project aside to dry.

wood icing and stencils

Oh, what a treat! I discovered this yummy product just a month before shooting the photos in this book, and even at that late-in-the-game stage, I knew it had to be a part of *Encaustic Mixed Media*!

Mary Beth Shaw, the popular and wonderful acrylic artist and author of *Flavor for Mixed Media*, has developed a delicious line of stencils manufactured to stand up to all kinds of mixed-media abuse. Not only do the designs make me sing happy songs, but the durability of the material has drawn silly-girl smiles on my face since the first trial run with wax.

And wood icing! I thought I'd tried everything available from the shelves of The Home Depot, but no. This happy partner to the aforementioned delicious stencils is not to be missed. Oh, the joy of putting these two wonders together in encaustic painting.

WHAT YOU'LL NEED

Encausticbord

Heat gun

Encaustic medium

Paintbrushes

Encaustic paint: King's Blue

Spray adhesive

Stencil (here, by Mary Beth Shaw)

Trowel

Wood icing

PanPastels

Sponge applicator

Masking tape

Razor blade

TOOLS OF THE TRADE
PanPastels are the best in the pastel world. Here I've paired them with Mary Beth Shaw stencils, wood icing and beeswax; it's like a party!

"Do not follow where the path may lead. Go instead where there is no path and leave a trail."
— HAROLD R. McALINDON

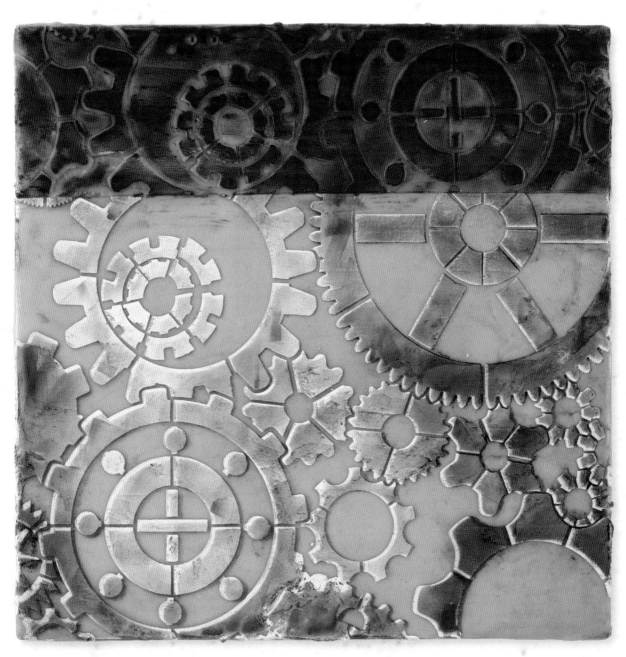

GEARED

Warm the Encausticbord with the heat gun.

Prime the board with a coat of encaustic medium.

Fuse this layer to the board with the heat gun. Over-fusing will make the finish smooth and even.

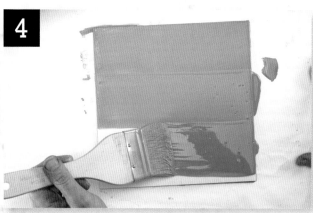

Apply a layer of encaustic paint. Here I applied King's Blue.

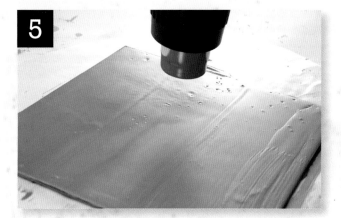

Fuse with a heat gun to eliminate brushstrokes and to bond the layers together. Let cool.

NOTE: Apply additional layers of paint, fusing between applications, until you are satisfied with the overall depth of foundational wax. There is no limit to depth other than your creative vision.

BRUSH UP

Don't worry if your encaustic paint bubbles up a bit while fusing—there's an easy fix for that! Just pop the bubble with a sharp tool, fill the bubble in with just a drop of encaustic paint and re-fuse.

6

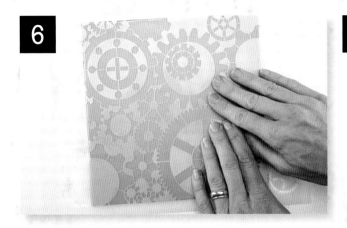

Spray adhesive on the back of the stencil and press the stencil into the surface.

7

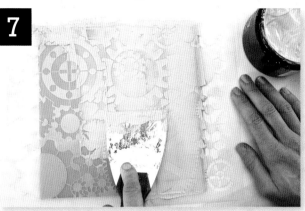

Using a trowel, apply a layer of wood icing over the stencil.

8

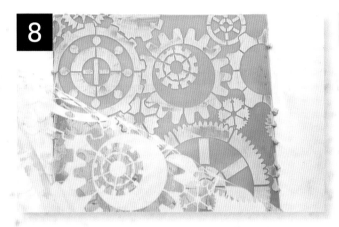

Immediately pull up the stencil. Set the piece aside to dry.

9

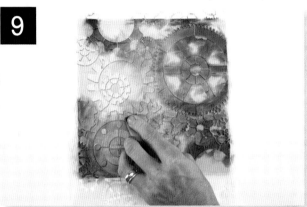

When the piece is dry, lay the stencil back on the board, lining it up with the previous positioning. Apply PanPastels evenly over the stencil to tint the wood icing design.

10

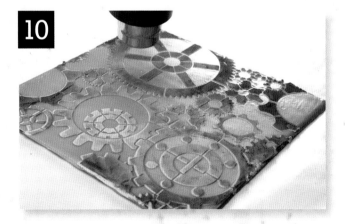

Add a layer of encaustic medium. Remove the stencil. Fuse the new layer of medium and the pastel to the surface using the heat gun.

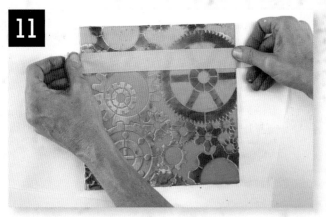

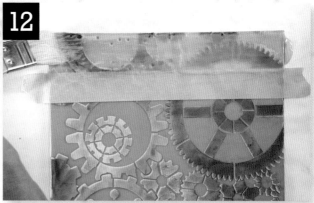

Apply masking tape. To accommodate the uneven surface of the stenciled area, press the tape into the valleys between the raised stencil areas. This prevents medium from bleeding under in the next step.

Apply a layer of encaustic medium to the area above the masking tape. You are building depth by doing this, giving the painting different depths for the eye to travel through.

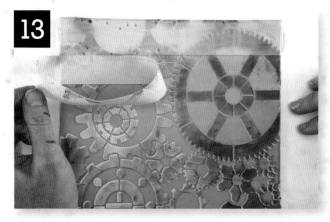

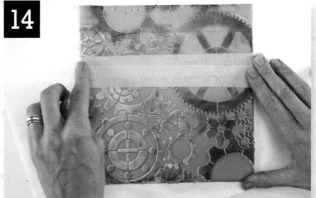

Remove the masking tape while the medium is still warm. Set the piece aside to cool.

> **NOTE:** Peeling away the masking tape while the wax is still warm will help keep edges crisp, but wax can still be delicate, so peel carefully.

Apply masking tape to the surface again, this time a few inches below the last application of tape.

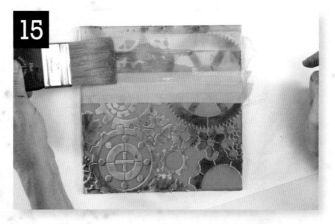

Apply encaustic medium to the area above the tape.

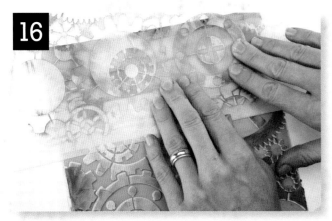

While the wax is still warm, reapply the stencil.

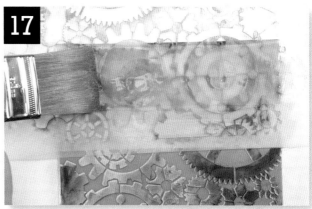

Apply another layer of encaustic medium over the stencil area.

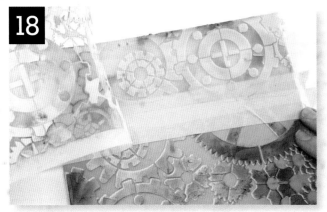

Peel away the stencil while the wax is still warm.

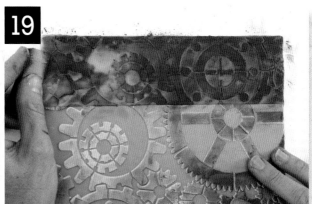

Remove the masking tape, allow the project to cool, and apply PanPastel to this upper portion.

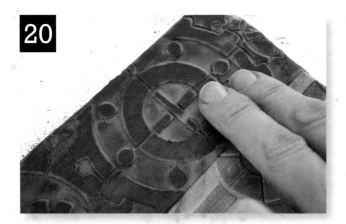

Rub the edges of the stenciled design with your finger. This will lift some of the pastel pigment and give the edges a distressed look. Clean the piece's edges as needed with a razor blade and heat gun to remove any wax overflow.

plaster

Just over a year ago, I began working with substances that would offer an interesting foundation in encaustic; enter plaster. I began with the dry mix-it, blend-it, try-to-get-a-good-consistency plaster of Paris. I discovered that, for my purposes, plaster of Paris was not what I'd hoped it would be. I quickly moved on to the much easier-to-use plaster spackles, joint compounds and patching plasters. Talk about cost effective, easy to use and wonderfully results driven!

These finds first captured my attention in the hardware store aisles during my 10-month stint as a full-time sign artist. I've been hooked on hardware store staples ever since, and I work with joint compound whenever I can. Unlike plaster of Paris, it does not require mixing to get the consistency I desire.

I choose to work this product on natural wood panels for the most part. Sometimes I use Encausticbords, but my most favored results with plaster come from the contrast of the white plaster against wood. It is best to start working with plaster several hours—if not a full day—ahead of when you plan to move to wax; it must have time to dry in order to offer the best adhesion.

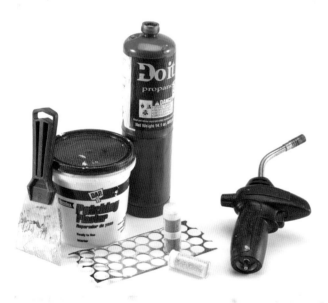

TOOLS OF THE TRADE
Punchinella (also called "sequin waste") takes center stage alongside hardware store plaster.

WHAT YOU'LL NEED

Art wood panel or scrap wood

Encaustic medium

Paintbrush

Heat gun

Repositionable spray adhesive

Punchinella

Masking tape

Trowel

Joint compound or patching plaster

Fire-retardant surface

Propane or butane torch

Metallic microbeads

Razor blade

"Most of the things worth doing in the world had been declared impossible before they were done."
LOUIS D. BRANDEIS

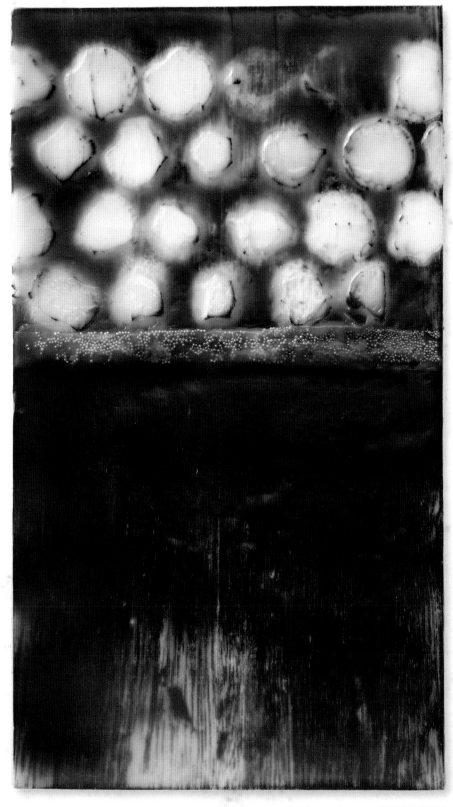

STORMY NIGHT

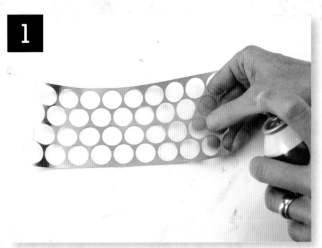

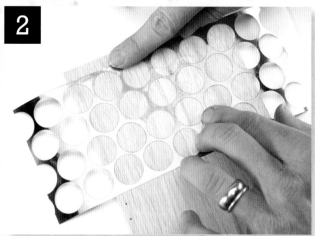

Spray the back of the Punchinella with adhesive to help prevent seepage.

Press the Punchinella onto the board.

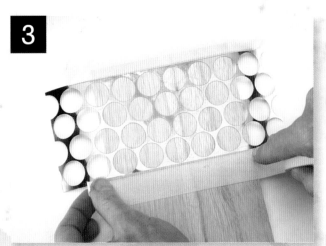

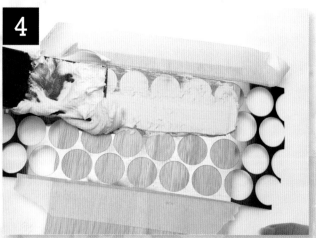

Apply masking tape above and below the area you intend to cover with plaster. This helps with alignment and prevents plaster from seeping under the Punchinella stencil.

Using a trowel, apply the plaster to the taped and stenciled area.

When the piece is completely dry, peel off the masking tape and the Punchinella stencil. This will create a chunky, broken texture effect.

NOTE: The stencil can be removed while the plaster is still wet for a smoother, more precise design.

Place the board on a fire-resistant surface. Fire the plaster and board with your torch, and then set the board aside. It needs to cool before having medium applied. The flame "toasts" the plaster, giving it an amber-tinted blush while scorching the wood to a rich black.

Add a layer of medium and fuse.

Mask off a stripe on the board, just below the Punchinella-plaster area. Warm the board with the heat gun.

Apply a thick brush full of medium to the masked-off strip to create a foundation for the metal beads to adhere to.

BRUSH UP

When applying a masking tape resist to the surface, make sure the tape extends off the sides of the board. It'll be easier to find and pull the end when you want to remove the tape.

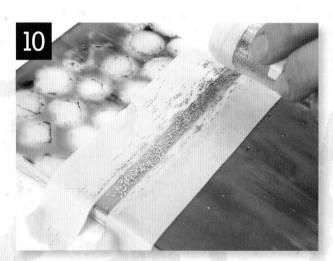

Carefully shake beads into the medium.

Press the beads into place.

Fuse the medium and beads using the heat gun. Start with the heat gun held high so the beads don't blow away. As they sink into the medium, move the heat gun closer.

Remove the masking tape. Set the piece aside to cool.

Clean up the surface and sides using the heat gun and a razor blade. Scraping with a razor blade over the Punchinella-plaster area can level out the wax and expose plaster if such an effect is desired.

tar

I knew I could find texture in the white, light backdrop of plaster, so why not try it in the deep, dark backdrop of tar? This medium can be manipulated in much the same way plaster can—with masking off, stenciling and burning. But as you can imagine, this is where the similarity ends. Tar, I've discovered, has a good friend in claybord. For this technique, even though I love Encausticbords, I return to my first love in claybord. The surface has a magical quality that emerges when combined with a wood-burning tool, and the contrast of black tar on white claybord can't be beat.

WHAT YOU'LL NEED
- Claybord
- Encaustic medium
- Paintbrushes
- Heat gun
- Masking tape
- Pigment ink stamp
- Wood-burning tool and tips (used for making duck decoys; I found it on the Internet)
- Punchinella
- Trowel
- Asphalt patch or tar
- Sandpaper
- Razor blade
- Stencil
- Encaustic paint: Payne's Gray
- Linseed oil
- Disposable cup
- Paper towels or rag

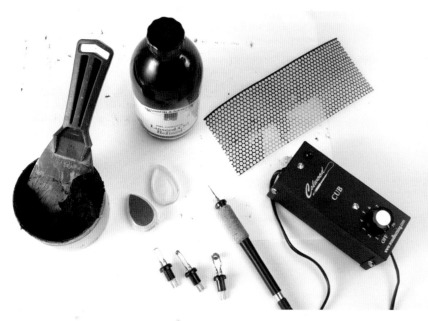

TOOLS OF THE TRADE
Tar, a wood-burning tool and craft elements come together to bring beauty and brawn to beeswax.

> **"Creativity is allowing yourself to make mistakes. Art is knowing which ones to keep."**
> SCOTT ADAMS

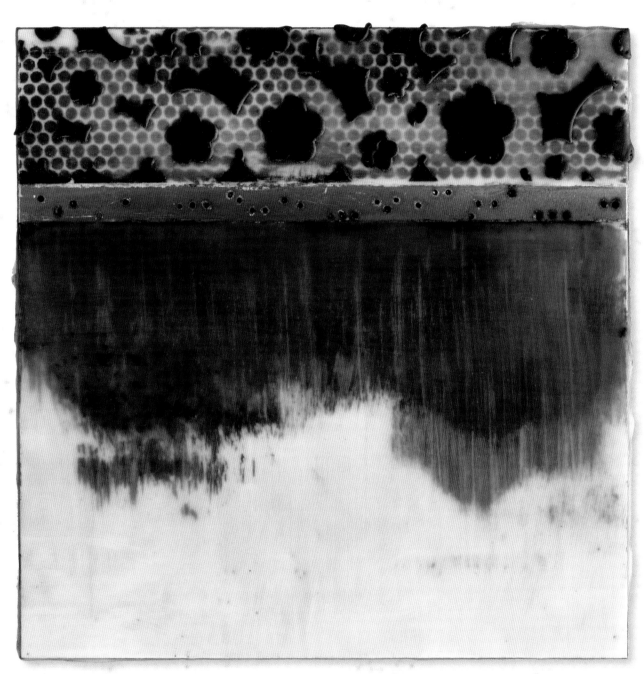

INDUSTRIAL LACE

Mask off a strip of the board. (These masks are simply for alignment; they won't be used as a resist.)

Apply ink to the taped-off area using a pigment ink of your choice.

NOTE: Watercolors, ink or pastel can all be used interchangeably here.

Use a wood-burning tool to burn circles into the wood. Use tongs to change tips on the burner when it is hot (tongs generally are included with the tool). Knock the board against a table to remove any ash. (Rubbing the ash away will discolor your board.)

Remove the masking tape from the board.

Mask over the inked-and-burned line to protect it, then place a resist (here, Punchinella) over the top portion of the piece. Using a trowel, apply tar over the resist and pull some tar down into the lower portion of the board.

Pull up the resist before the tar hardens. If the tar is allowed to dry before the resist is removed, it may be stuck permanently in the tar.

7

Allow the tar to dry completely. Sand the sides and along the top of the board to remove loose bits of tar and give the tar different tones of black.

BRUSH UP

To remove the tar, you could also scrape it with a trowel to achieve a similar effect, but it might pull up more than you'd like.

A trowel will also leave staining behind, resulting in a mellow look with less contrast.

8

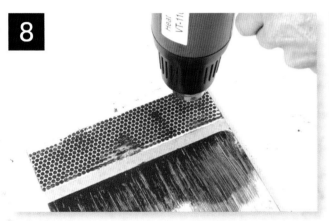

Mask the inked-and-burned line again; this time you'll be building up encaustic layers on either side to provide a sense of depth. Heat the board with the heat gun.

9

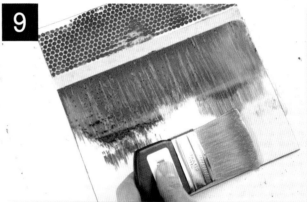

Apply encaustic medium over the entire surface.

10

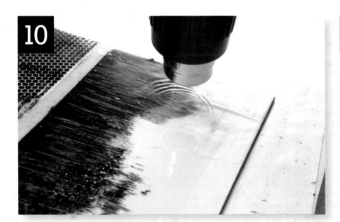

Fuse with the heat gun and smooth out any texture resulting from the application of the medium. Repeat steps 9 and 10 until you are satisfied with the overall look and thickness of wax.

11

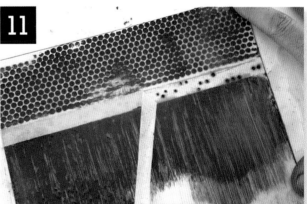

Remove the masking tape while the wax is still warm.

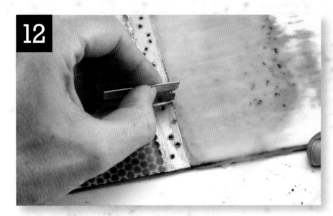

If medium bleeds under the tape, scrape it off the inked-and-burned area with a razor blade.

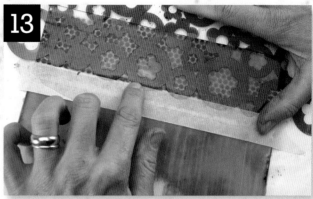

Tape a stencil over the top part of the board. Taping the stencil will help keep edges clean and hold the stencil down.

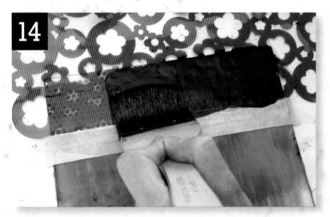

Paint over the stencilled area with Payne's Gray encaustic paint.

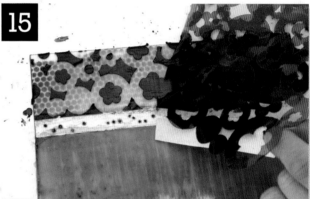

Immediately peel away the stencil.

alternate approach

An alternate approach to steps 13 through 15 is to incise around the stencil and apply a pigment stick.

WHAT YOU'LL NEED

Awl or stylus

Pigment stick

Paper towel

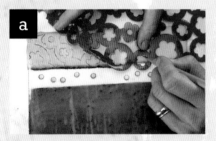

Lay the stencil into the warm wax. Use an awl or stylus to trace around the stencil. You may get burrs, but you can just brush those off once the wax has cooled.

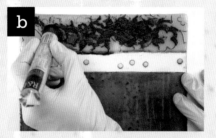

Apply a pigment stick over the cooled, incised wax. Rub the pigment into the surface with gloved fingers (to prevent pigment from absorbing into skin).

Wipe away excess color with a paper towel.

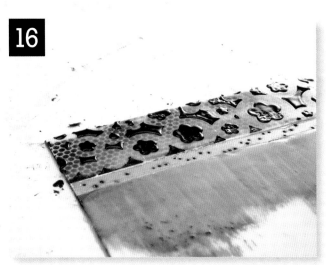

16

Fuse this layer with the heat gun.

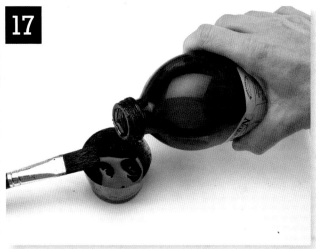

17

To create a rich, dark stain that can be used to tint the painting for it a vintage feel, mix a small dollop of tar with some linseed oil in a disposable cup.

> **NOTE:** This mixture can be set aside to dry and left for months, and it will still be viable—just add fresh linseed oil.

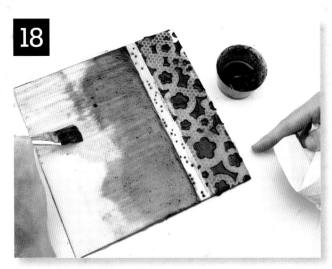

18

Apply the tar-and-linseed oil mixture with a paintbrush. (You could use oil paint, but I liked the continuity of tar in its different manifestations.)

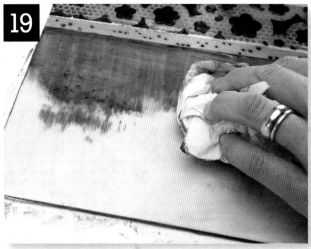

19

Rub this stain into the wax using a paper towel or rag. Because of the linseed oil, the piece will need a couple of days to dry.

watercolor

I began my foray into art via mixed media on watercolor and printmaking papers. I adore the texture, absorbency and tooth of these papers and was enchanted by the play of fluid colors over the surfaces. As a result, I have a pile of paintings reaching to the tip of my one-year-old niece's nose!

I was determined to whittle the pile away. But how? I couldn't toss the paintings; they were too pretty. I couldn't frame them; they weren't quite "there." I knew I wouldn't continue to work on them; I was fully invested in encaustic.

In keeping with this project's quote, I went with a hunch.

I took that pile, and I began to tear. Harkening back to my fiber art days, I wove them into interesting designs. Unable to stop there, I took the torch to them. The result was a very satisfying, truly yummy repurposing of these mixed-media masterpieces into foundations for encaustic inspiration. Yum yum.

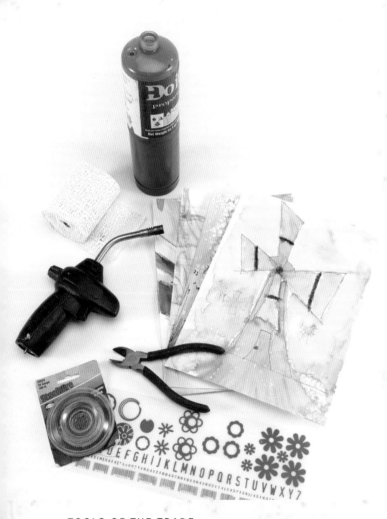

WHAT YOU'LL NEED

Claybord

Encaustic medium

Paintbrush

Heat gun

Cut or ripped strips from an old watercolor painting

Gel medium

Fire-retardant surface

Propane or butane torch

Rigid wrap embellishments (see page 105 for mini demo)

Rub-on transfers

Annealed steel wire

TOOLS OF THE TRADE
Pulling other mediums into encaustic in a unique repurposed way! And of course, putting the torch to play.

"A hunch is creativity trying to tell you something."
FRANK CAPRA

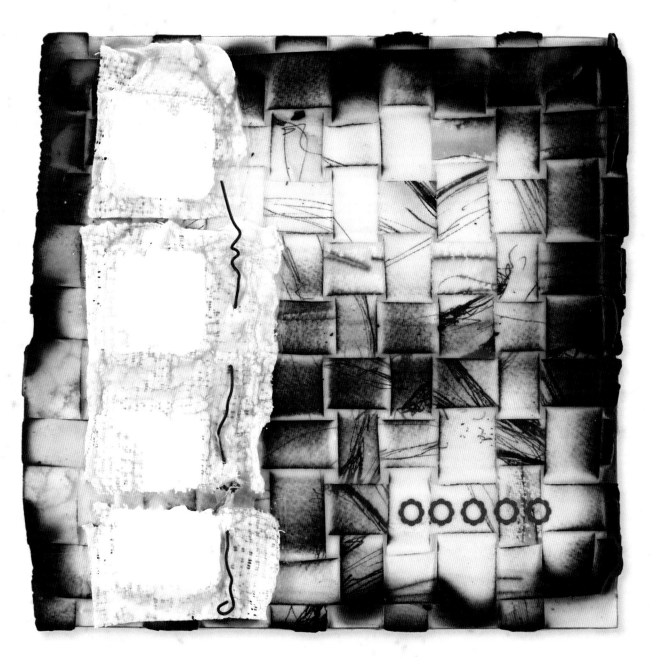

CASTING ABOUT

Weave the strips of painting together, first arranging the vertical strips, and then weaving the horizontal strips through the vertical strips.

Apply gel medium to the board using a paintbrush to evenly coat.

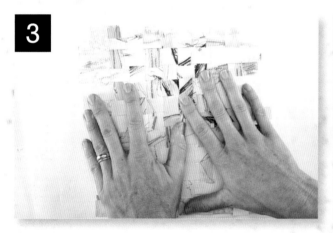

Lay the woven painting over the board, pressing it into the gel medium, and then weigh the painting down and let it dry, preferably overnight.

NOTE: Before you proceed to the next step, make sure the gel medium is completely dry. You don't want moisture below the layer of wax you will apply.

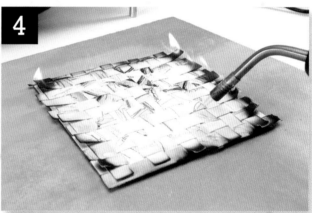

When dry, lay the piece on a fire-retardant surface. Using a butane or propane torch, burn select areas of the painting.

NOTE: I left the woven edges overhanging when gluing so I could burn them back in a more loose and inexact way.

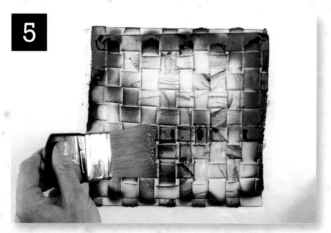

When the piece has cooled off some (but is still warm to the touch), apply encaustic medium.

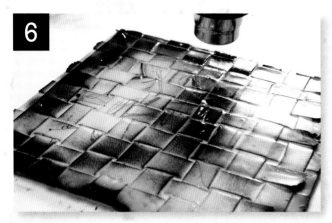

Fuse the wax layer using the heat gun.

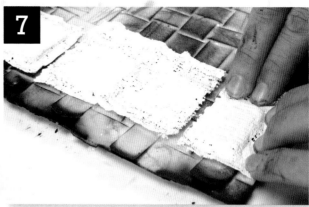

Place and press the rigid wrap embellishments into the still-warm surface.

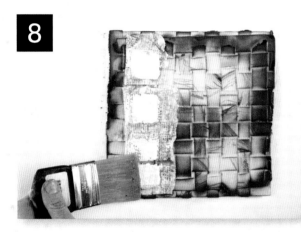

Add a layer of encaustic medium over the forms.

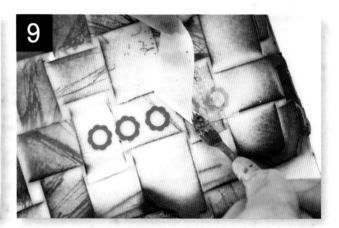

Use homemade or craft store rub-ons to embellish the painting. Simply rub them onto the cooled wax.

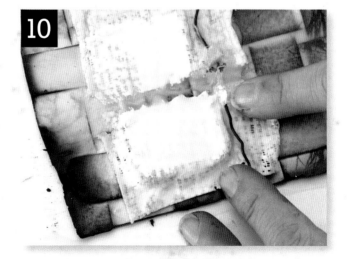

I felt the piece wasn't quite done yet, so I chose to thread a length of wire through the rigid wrap forms while the wax was still warm.

cork

I can remember cork lining many of the shelves in my childhood home. I think it began as a means to safely secure dishes and glasses that might otherwise slide perilously on a slick cupboard shelf.

Whatever the intended purpose, the person who first considered the possibilities for cork in the world of arts and crafts deserves a commendation! I adore the look of it in encaustic.

The mottled tan texture of adhesive-backed cork "paper" is a welcome addition that can be manipulated with hole punches, craft punches or, best yet, a Sizzix die-cut machine (check out the mini demo on page 106). This cork "paper" rolls through the die-cut machine with little effort and rewards determined crafters with a delightful variety of embellishments to embed in their next encaustic creations.

WHAT YOU'LL NEED

Cradled Encausticbord

Encaustic medium

Paintbrushes

Heat gun

Masking tape

Die-cut self-adhesive cork embellishments (see page 106 for mini demo)

Disposable cup

Tar

Linseed oil

Paper towel

Rusted Wholey Paper (see page 105 for mini demo)

Resin embellishment (see page 110 for mini demo)

Scraper or double-ended stylus

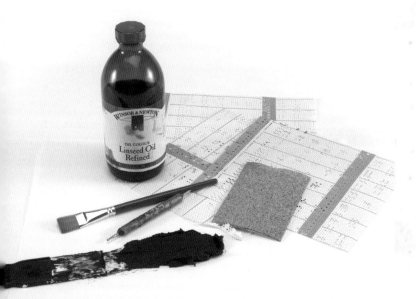

TOOLS OF THE TRADE
Wax, resin, cork, rusted paper: truly mixed-media extraordinaire!

> **"Every act of creation is first an act of destruction."**
> PABLO PICASSO

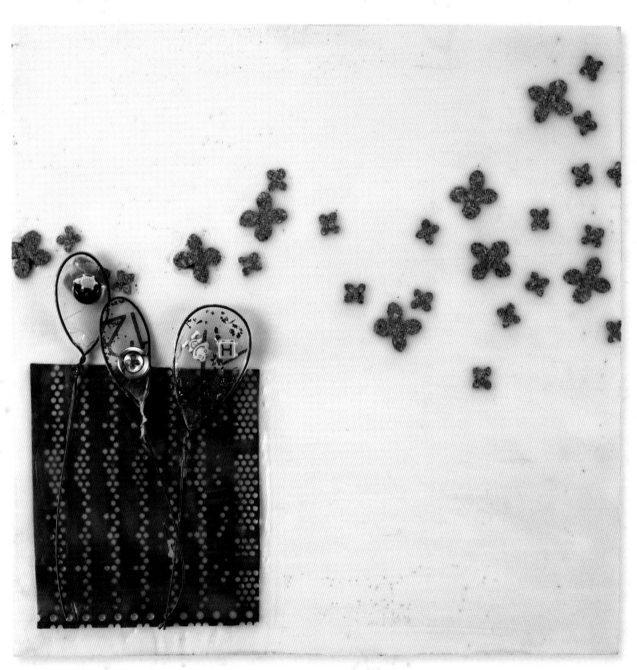

BUTTERFLY CATCHING

Tape the edges of the cradled board with masking tape. This will protect the edges from wax drips.

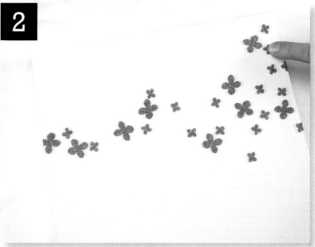

Apply the die-cut cork embellishments to the surface.

NOTE: Most cork I've seen is self-adhesive. If yours is not, don't worry. Simply adhere the cork embellishments to the surface with gel medium.

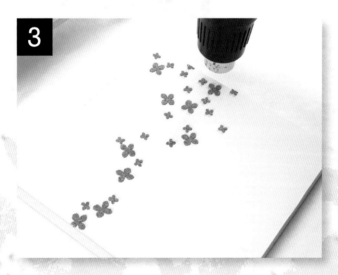

Warm the board with the heat gun.

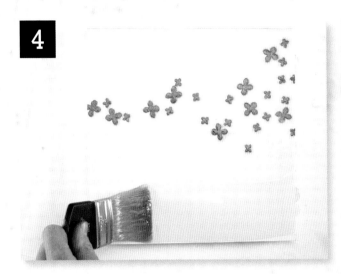
Apply medium in even strokes over the entire surface.

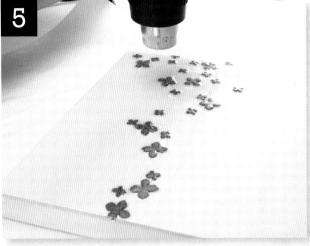
Fuse this medium layer and allow it to cool.

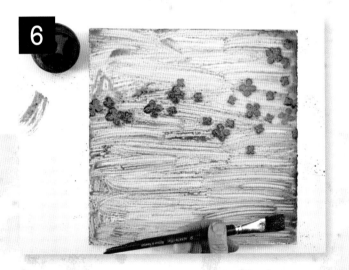
In a disposable cup, mix the tar with linseed oil (see page 61). Apply a layer of tar paint over the entire surface to tint the wax.

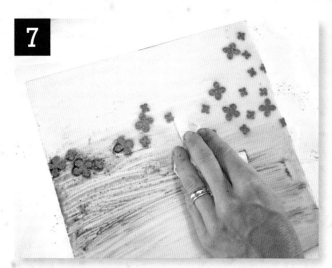

7

Remove any excess tar tinting with a paper towel.

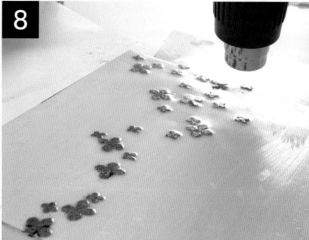

8

Use the heat gun to fuse this added layer.

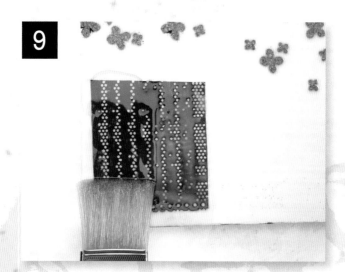

9

Press the rusted Wholey Paper into the still-warm surface, and then apply a layer of medium over the Wholey Paper.

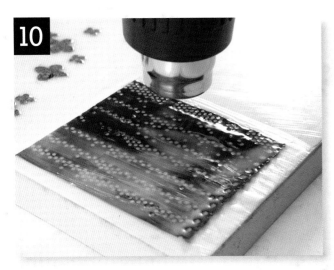

Fuse the wax and Wholey Paper to the surface with the heat gun.

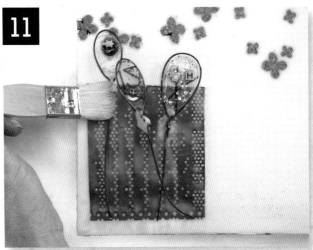

Place the resin embellishments on the surface and dab wax over the stems to secure.

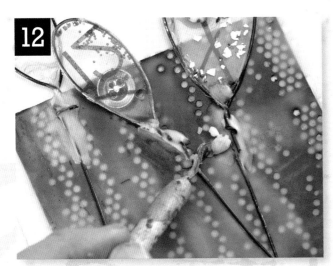

Use a double-ended stylus or scraper tool to remove any excess wax from the embellishments if desired.

Remove the tape from the edges and set the piece aside to cool.

fabric

Since seventh-grade home economics, I have been infatuated with the sewing machine. It was then that I learned straight-seam sewing and took on the arduous task of making my own dress for the dance. It was a Gunne Sax–inspired number with yards and yards of long flowing skirt. I succeeded in completing it and wore it proudly. It still resides in a box in my attic!

I've scaled down my sewing since then; first in clothing for my four boys when they were toddling about, and now in doll-sized patterns to stitch and embed in wax. Combining such a long-beloved medium and encaustic is a goose-bumping thrill. I was unequivocally giddy when I developed this series I call "Apron Strings" while on an extended stay at Sitka Center for Art and Ecology on the Oregon coast. The gloriously unstructured time devoted entirely to creating and the inspiring rustic space (I warmed myself over the wax palette and wood stove interchangeably) helped produce these delights.

The series continues to evolve, but I couldn't resist sharing my first discoveries here. You, too, should be inspired to try thread, fabric, felts and anything else in the fabric store that catches your eye.

WHAT YOU'LL NEED

- Cradled Encausticbord
- Encaustic medium
- Paintbrush
- Heat gun
- Home decorating–weight fabric cutouts in dress and apron shapes
- Thread (optional)
- Tweezers or tongs
- Masking tape
- StazOn ink pad
- Rubber stamps
- Stylus
- Pigment sticks
- Rubber gloves
- Paper towels
- Paper embellishments
- Small finishing or decorative nails of your choice
- Small beads (will serve as spacers)
- Hammer
- Needle-nose pliers
- Mini clothespins
- Gel medium

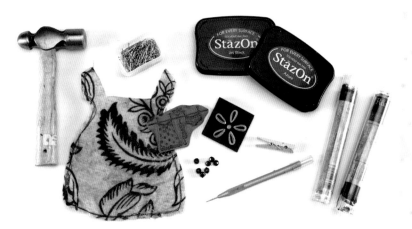

TOOLS OF THE TRADE
An interesting array of tools—fabric cutout, pigment sticks, hammer and nails. This piece satisfies my inner seamstress, handyman and artist!

> "It is threads, hundreds of tiny threads, which sew people together over a lifetime."
> SIMONE SIGNORET

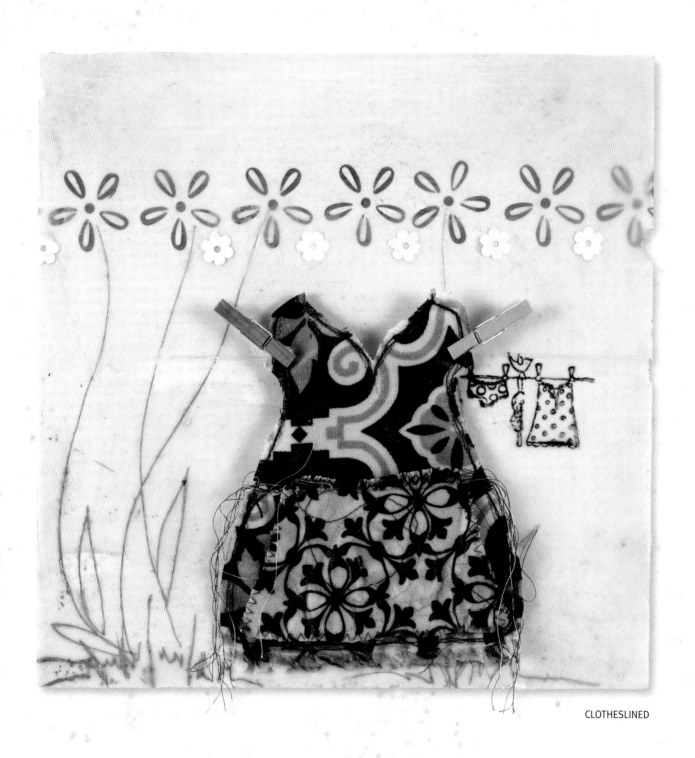

CLOTHESLINED

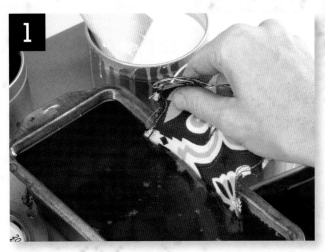

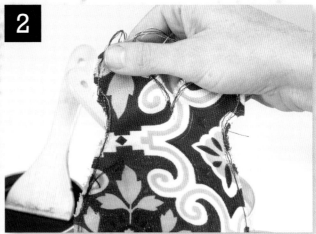

If you like, you can add stitched details to the dress and apron shapes using complementary thread. Then gently dip one side of the dress into the medium, using tweezers or tongs.

> **NOTE:** I chose to dip the cutout for the beauty of the effect, but the process can be skipped without losing anything.

Lift the dress from the medium and let the excess drip off.

BRUSH UP

Silks and synthetics (like polyester and rayon) will darken, practically to black. This can still look great, but don't let yourself be surprised.

Run a quick test: Submerge a scrap of your chosen fabric in water. The color you see when the fabric is wet is the color you'll get (permanently!) after it's dipped in wax.

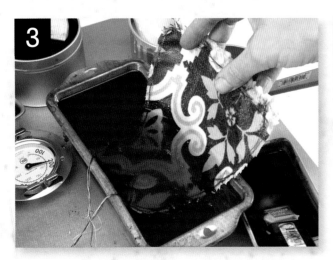

Gently dip the other side of the dress into the medium using tweezers or tongs. Set it aside to cool. Repeat steps 1 through 3 for the apron and set it aside to cool.

Cover all the sides of the cradled board with masking tape to prevent them from being splashed or dripped with wax.

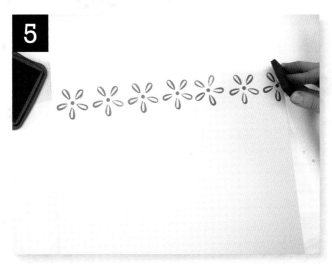

Apply ink to a flower stamp and stamp the design across the board.

Warm the board with a heat gun.

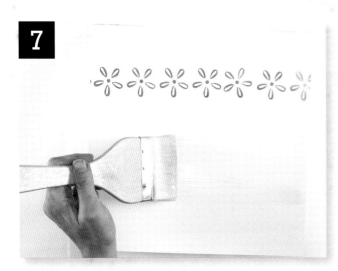

Apply the medium over the surface of the board in even, side-by-side strokes.

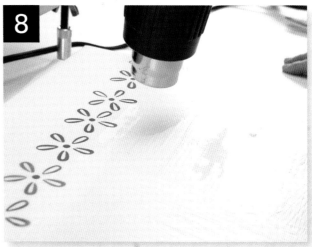

Fuse the wax to the surface of the board.

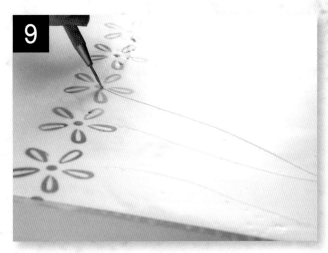

9

Incise the wax with a stylus, adding stems to the stamped flowers. To prevent cracking, this should be done while the wax is still warm. Set the piece aside to cool completely.

10

Using a pigment stick, apply color over the cooled surface. I used two colors here—Burnt Sienna and Neutral White. Rub the color into the wax with your gloved fingers, and then pull up excess color using a paper towel.

NOTE: Use vegetable or linseed oil with a paper towel to aid in color removal, if desired.

BRUSH UP

Refresh your paper towel often to get the best results when removing pigment.

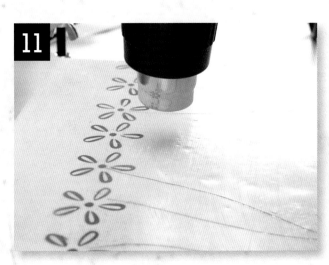

11

Fuse the pigment into the encaustic medium with a heat gun.

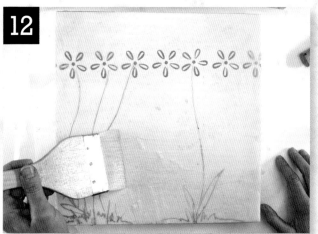

12

Apply another layer of encaustic medium over the surface of the board. Some movement of pigment may occur; if you'd like to avoid this, allow the pigment to dry thoroughly—a day or two—before moving to this step.

Fuse this new layer with a heat gun.

Incise a line in the warm wax for the clothesline, and then apply Neutral White pigment stick over the line.

Use a paper towel to remove excess pigment.

NOTE: Wax is very forgiving—I can scrape it off, heat it off or wipe it off. I can even come back years from now and make adjustments to it if I want.

Ink a clothesline stamp and apply the stamp to the surface of the board, onto the wax.

Press the paper embellishments (here, flowers) onto the surface and cover with encaustic medium. Fuse with a heat gun.

Push a nail through the top corner of the apron and slide a bead onto the nail. The bead will serve as a spacer. Repeat on the other side of the apron shape.

BRUSH UP

It can be very difficult to pound the nails through the Encausticbord because it has hardboard, as opposed to wood, as its base. Typically for this type of project, I work on a wood panel. If you choose to work with Encausticbord, it might be helpful to drill holes into the board before nailing the dress into place.

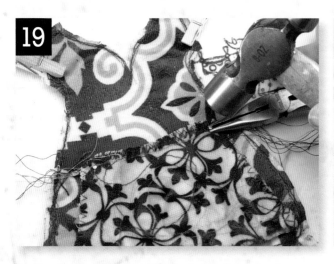

Position the dress (with clothespins) over the clothesline. Line up the apron and nail everything into place, using needle-nose pliers to hold the nail in place.

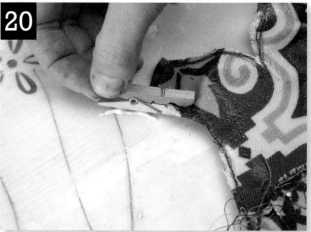

Use gel medium to secure the clothespins to the surface.

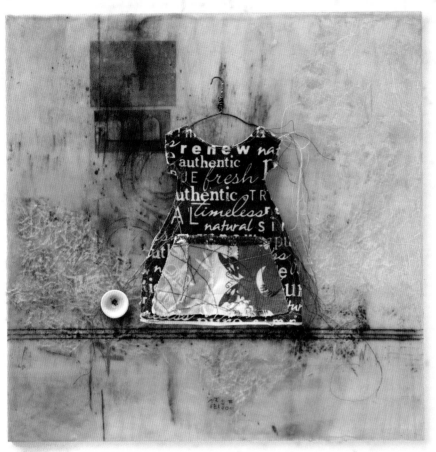

APRON STRINGS IN THE PANTRY AND NATURAL HABITAT

Both of these evolved from my time at Sitka and are part of the *Laundry Day in Apron Strings* series. *Apron Strings in the Pantry* utilizes a pounded metal wire hanger with burn elements and charcoal on raw board. *Natural Habitat* shows off a Punchinella dry-brush center and computer hard drive components.

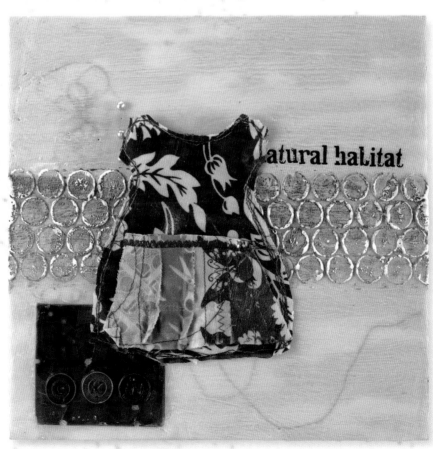

claybord box with lid

I'm all about versatility. Blame it on having four boys in six years or on having moved a dozen times in my life or perhaps just on my middle-child positioning in the family lineup. Regardless, versatility and flexibility reign in my life.

It's fun to realize that a favorite manufacturer or product line feels the way I do. Discovering that my favorite surface, claybord, came not only in the traditional panel, but also in assorted shapes and dimensions was enough to intrigue me; discovering this same delicious surface in a box top sent me over the moon! It's been fun to bring the beauty of beeswax to something besides a traditional wall-hung art piece.

For the box tops, I've enjoyed staying with established encaustic techniques, letting the beautiful shape speak just as loudly as the encaustic painting on top. The sides are a fun place to experiment with other mediums; my good friend shellac is great for added punch!

The letterpress set is from my dad, who was a mechanical engineer. It was used to press serial numbers into metal. You can find similar letterpress stamps at craft stores in the scrapbooking aisle.

WHAT YOU'LL NEED

- Claybord box
- Encaustic medium
- Paintbrushes
- Heat gun
- Straightedge
- Wood-burning tool
- Razor blade
- Metal letterpress stamps
- Oil paint stick in black
- Rubber gloves
- Rusted felted floral tape (see page 105 for mini demo)
- Paper towels
- Gel gloss medium
- Glass disk embellishments

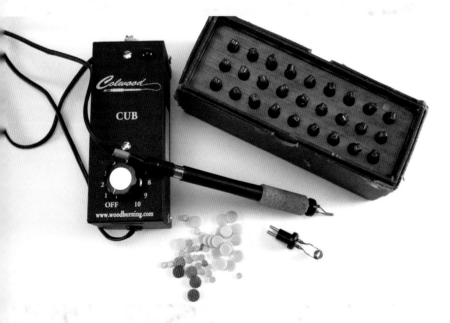

TOOLS OF THE TRADE
Part of me wishes I was more of a pack rat so that I'd have kept more of the tools and found objects that my parents and grandparents left behind. Nonetheless, I am blessed to still possess this old machinist's letterpress set from my dad—just don't tell my oldest brother! He may think it's still in his tool stash!

> "Creativity is the ability to see relationships where none exist."
> THOMAS DISCH

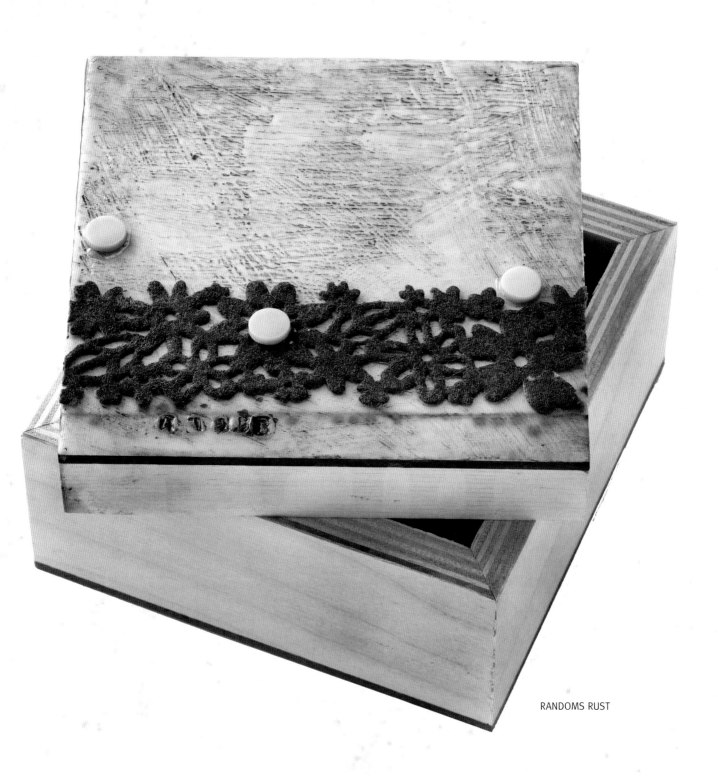

RANDOMS RUST

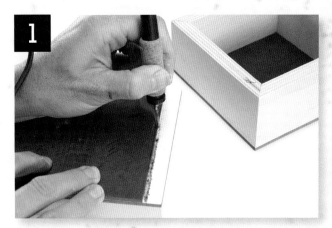

Using a straightedge (I use another claybord as my straightedge) and a wood-burning tool, burn a line into the claybord lid.

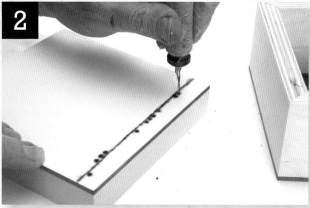

Continue burning until you are satisfied with the look of your lid. Here I placed irregular marks along either side of the burned line.

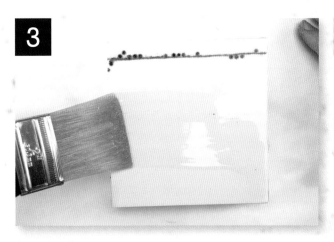

Apply encaustic medium to the lid in even strokes.

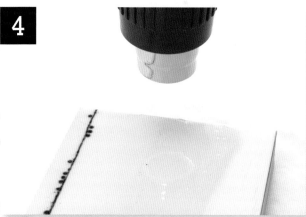

Fuse with the heat gun. Scrape any excess wax from the edges of the lid using a razor blade as needed.

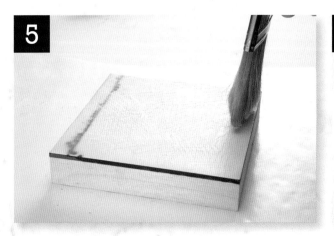

Apply another layer of medium to the lid, allowing the brushstrokes to show and creating a more textural layer.

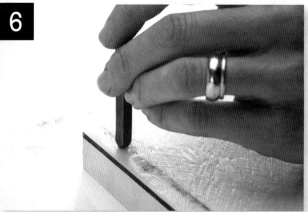

Press metal letterpress stamps into the slightly warm wax.

7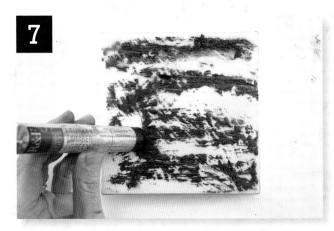

When the wax is completely cool, smear a paint stick across the surface of the wax/letters/lid.

8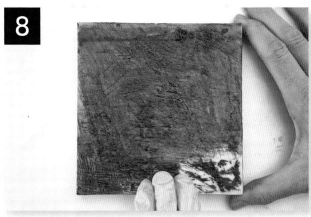

Rub the paint into the wax layer with your gloved fingers.

NOTE: When working with oil paints, it's best to wear gloves, because your skin can absorb some of the pigment.

9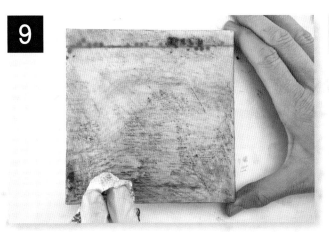

Rub with a paper towel to remove any excess color.

10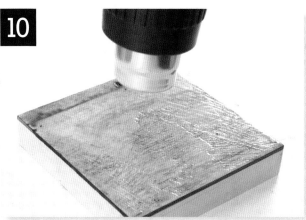

Fuse this oil layer to the wax below with a quick hit from the heat gun.

11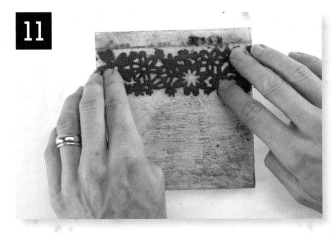

Press the rusted felted floral tape into the still-warm wax. Use a razor blade to trim the edges of the tape.

12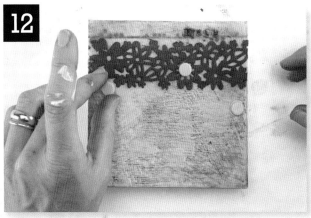

Apply gel medium to the backs of the glass disk embellishments, and then place them on the surface of the lid as desired.

shadowboxes

Pull up a chair! Moodling happens here!

Just imagine the delightful thoughts that would roll through your brain as you lounge in these retro comforts.

I discovered these miniature chairs when I went looking for doll-sized dress forms (which the manufacturer also supplies). To my delight, they fit just perfectly into Ampersand shadowboxes, and it was all I could do to stop at just one. So I didn't! I went for a collection instead!

Utilizing pebble-textured paper to hint at retro wallpaper and foil leafing to play into the decorating sense indicative of the 1960s and 1970s, I fully indulged in just how delightful these miniatures are and how much fun it is to incorporate them into encaustic.

In the end, I have a group of nine boxes, grouped together to show off their retro goodness. Here you see four of the remaining delights. Makes me want to go back in time a bit just to sit for a spell.

WHAT YOU'LL NEED

Shadowbox

Gel medium

Heat gun

Paintbrushes

Pebble-embossed decorative paper

Scissors

Masking tape

Encaustic paints: Indian Yellow, King's Blue, Quinacridone Magenta, Titanium White

Scissors

Gold leaf (Simple Leaf)

Drill and ³⁄₁₆" (5mm) drill bit

28-gauge steel wire

Wire clippers

Miniature display item (here a miniature replica 1960s chair)

TOOLS OF THE TRADE
Retro tools for a retro project. Note the pebble paper; oh, those 1970s wallpaper patterns!

"So you see, imagination needs moodling—long, inefficient, happy idling, dawdling and puttering."
BRENDA UELAND

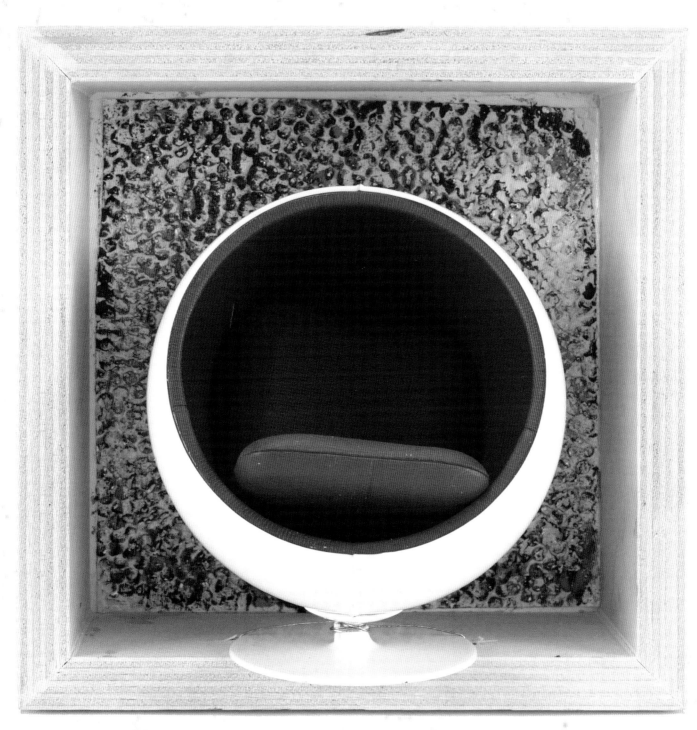

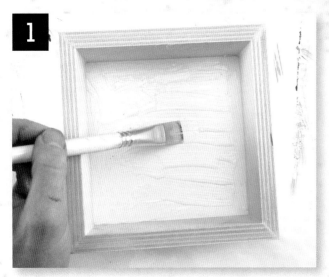

Apply gel medium evenly over the back surface of the shadowbox using an old brush.

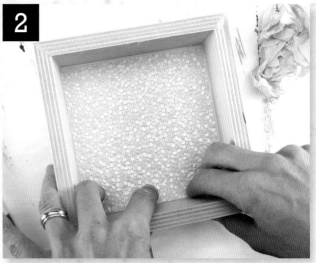

After cutting the pebble-embossed paper to size, press the paper into the gel medium.

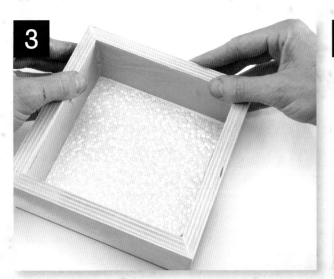

Apply masking tape to the interior edges of the shadowbox. This will help keep them clean while you're applying encaustic paint. (Because you will hit the sides, no matter how careful you try to be!)

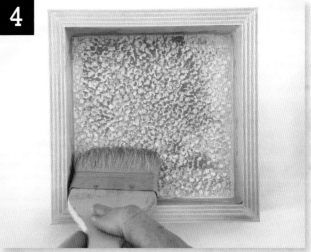

Because you will be creating a dry-brush effect, leave the surface cold; don't heat it. Remove your brush from the Indian Yellow encaustic paint, scraping as much paint from the brush as possible. Lightly run it over the embossed paper. The wax will catch on the surface of the embossed design, but it won't seep into the crevices. Apply the second layer in the same manner, using King's Blue.

5

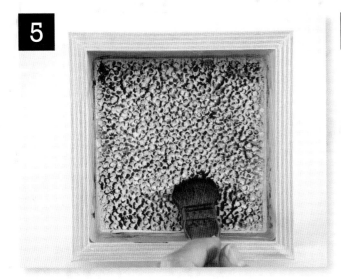

Continue using the dry-brush technique to apply the third layer of encaustic paint, this time Quinacridone Magenta.

NOTE: Keep applying more layers of these three colors to achieve a complex, multilayered look.

6

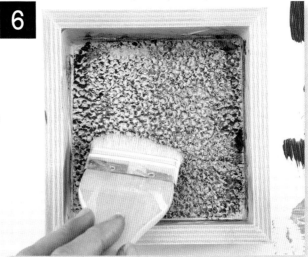

Use the dry-brush technique to apply a final layer of encaustic paint, this time Titanium White. Set the piece aside and allow the wax to cool completely.

7

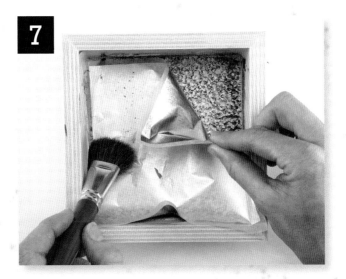

Lay the gold leaf over the embossed surface, foil side down, and pounce the back with a soft-bristled paintbrush to transfer. When you remove the sheet, just a touch of leafing will have transferred onto the raised area of the embossed paper.

8

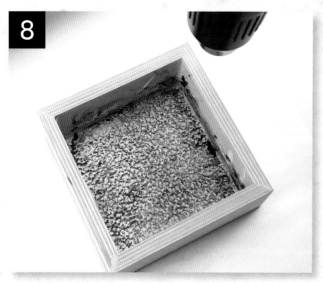

Warm with a heat gun so the warm wax will hold onto the gold leaf.

9

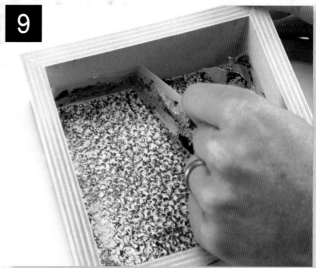

Remove the masking tape.

10

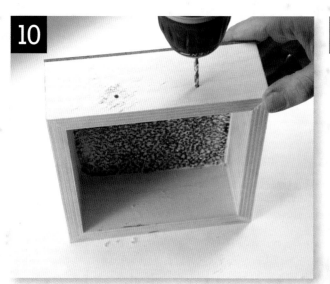

Mark the placement of the chair's base on the underside of the shadowbox; drill two holes using a ³⁄₁₆" (5mm) drill bit.

11

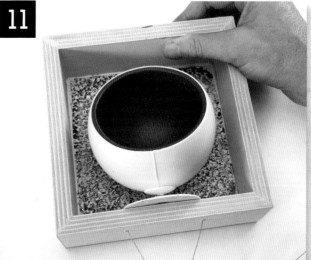

Clip a length of wire. Thread it through one hole, wrap it around the base of the chair to secure it, and then thread it through the second hole. Twist the ends of the wire together and clip any excess.

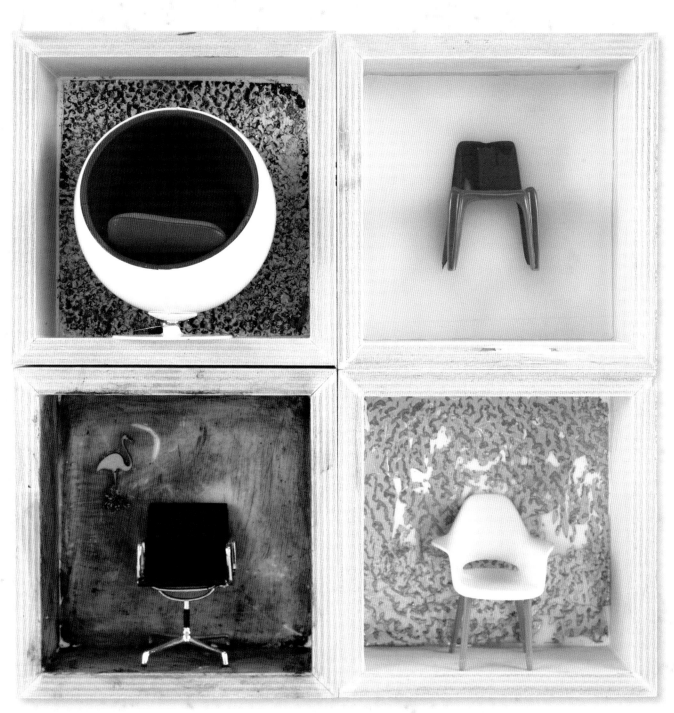

EVOLUTION AND STYLE
I brought this funky collection of items together by grouping them and giving the group a collective title. Not all the chairs were wired in; two were embedded in wax and one was glued with gel medium.

artist trading cards

Since beginning in encaustic—in mixed-media work, as a matter of fact—I have been in love with Ampersand claybord. Although this surface is not every encaustic artist's choice for substrate, I could find a love for no other and steadfastly stood by its beauty. I feel this faithful allegiance has been rewarded this year as Ampersand and R&F Handmade Paints paired up to create Encausticbords.

This board marries the best of the best: encaustic gesso and a unique, effective application process. The result is a gorgeous smooth, white, absorbent delight. I frequently take the boards out of their packages and just let them sit in a row on the table for a day before applying wax; they are just that pretty!

And now this surface is available in a multitude of shapes and sizes. One of my favorites is the trendy and popular Artist Trading Cards. The possibilities with business-card sized boards are endless! However you go about painting on these ATCs, I hope you find them to be as thrilling as I do.

WHAT YOU'LL NEED

Claybord ATCs

Encaustic medium

Paintbrush

Heat gun

Masking tape

Chipboard shapes

Spray ink

Contact paper stencil

Encaustic paint: Quinacridone Magenta

Metallic powder

Stylus

Decorative paper, cut into strips

Paper punches

Razor blade

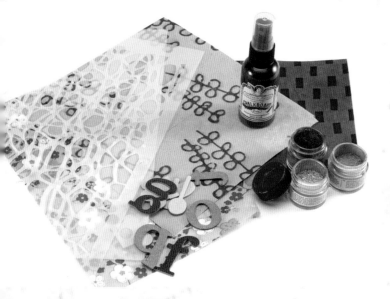

TOOLS OF THE TRADE
Chipboard letters, metallic powder, spray ink, decorative paper and stencils.

> "Creativity is not the finding of a thing, but the making something out of it after it is found."
> JAMES RUSSELL LOWELL

ALPHABET SOUP

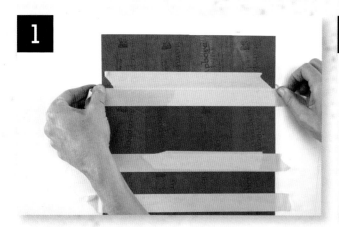

Using masking tape, join all the ATCs together along the back of the boards so you can paint them as a single unit.

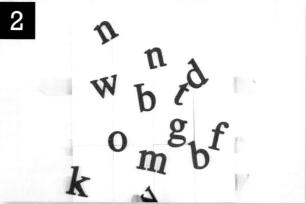

Flip the taped boards over. Arrange chipboard shapes (I used letters) over the surface; try to ensure that no ATC is untouched.

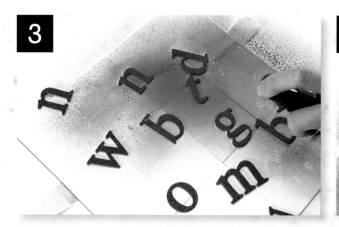

Spray ink over the surface and then allow to dry.

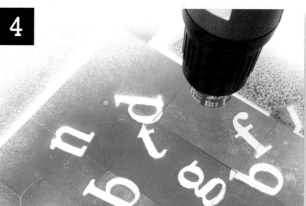

Remove the chipboard shapes. Warm the boards using a heat gun to prepare for the application of medium.

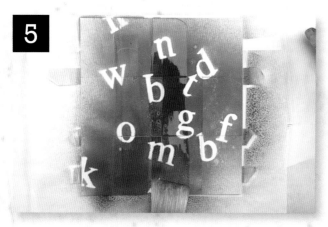

Apply medium over the boards.

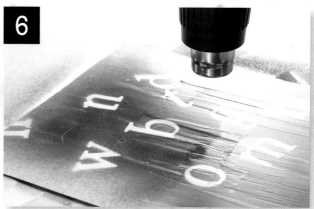

Fuse the medium to the boards using the heat gun.

7

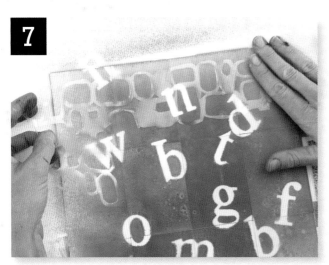

Apply the contact paper stencil over the boards, pressing gently to adhere.

8

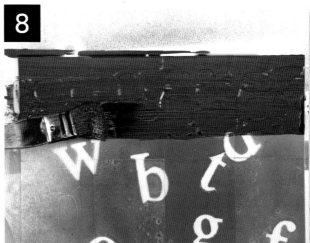

Paint Quinacridone Magenta encaustic paint over the stenciled area.

9

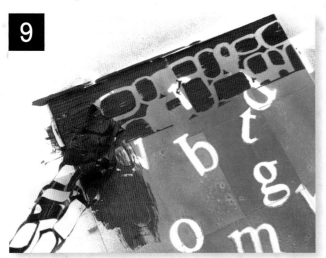

Immediately peel up the contact paper stencil.

10

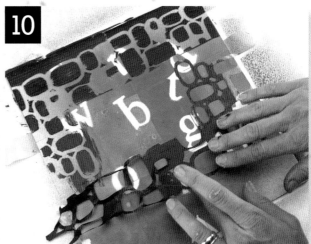

Reapply the stencil to the board in a different position.

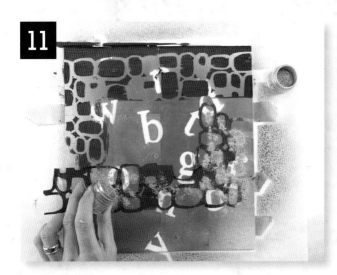

Sprinkle metallic powder over the surface of the stenciled area.

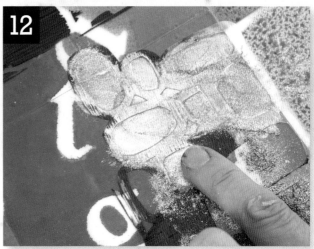

Spread the powder over the surface using your finger.

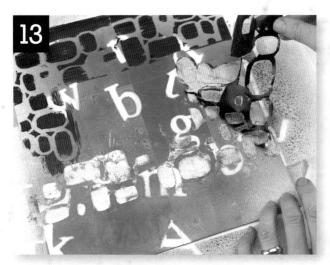

Peel up the contact paper.

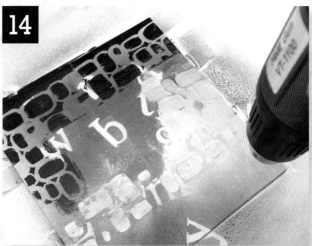

To fuse the powder and wax, you'll need to hold the heat gun higher up so the powder will adhere to the melting wax without blowing away. As the powder adheres, you can move the heat gun closer to the surface.

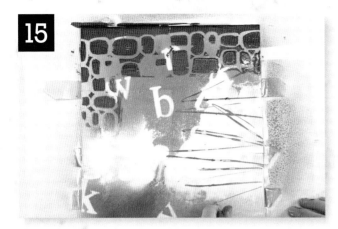

Scratch through the warm wax layers with a stylus for a textured effect.

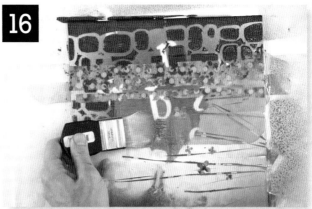

Use a paper punch to cut out shapes from the decorative paper strips. Apply the paper strips and cutouts (flower-shaped cutouts in this instance) to the surface. Apply medium over the papers and cutouts first, and then over the entire piece.

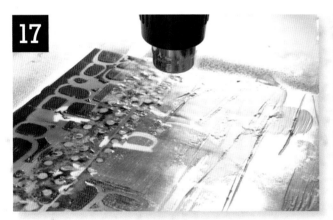

Fuse the new layers of medium to the board.

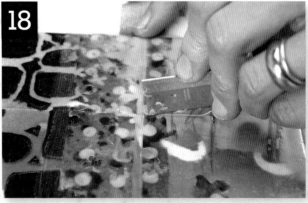

Cut through the paper, tape and wax by scoring the surface with a razor blade along the edges of the individual ATCs.

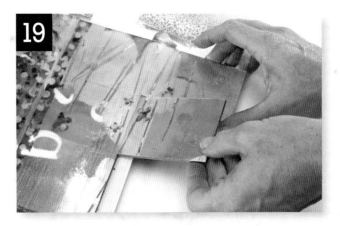

Gently lift each board from the tape.

wood pages

Escape into a good book in an entirely different way!

Indulge in uniquely luminous pages. Flip through to find the delight in the story of each. Reinvent your creative inspiration when you take these small wonders into the studio.

Judy's Stone House Designs brought me to these projects by way of pre-made book forms of birch panels. I've had a great deal of fun exploring the possibilities of wood burning, mark making, book binding and more with the various book-form designs offered by Judy's. I encourage you to indulge as well by escaping into a good book!

WHAT YOU'LL NEED

Wood book form, pages separated

Encaustic medium

Paintbrushes

Heat gun

Punchinella

Encaustic paints: Indian Yellow, Quinacridone Magenta, King's Blue, Titanium White

Encaustic-dipped wire and paper bead embellishment (see page 112 for mini demo)

Burned paper pieces (see page 108 for mini demo)

Found-object embellishment

Spray ink

Rusted felted floral tape (see page 105 for mini demo)

Stylus

Yupo embellishments (see page 109 for mini demo)

Markers

Charm embellishments

PanPastels with sponge applicator

Gold leafing (Simple Leaf)

Craft stick

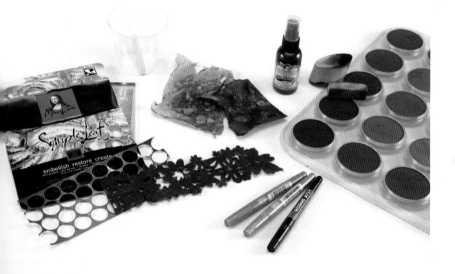

TOOLS OF THE TRADE
Beads, rusting, gold leaf, embedding, die cuts: All the best embellishments come together in this book-form showcase.

"A great book provides escapism for me."
WENTWORTH MILLER

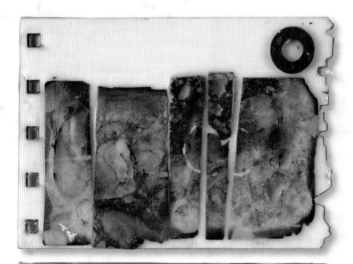

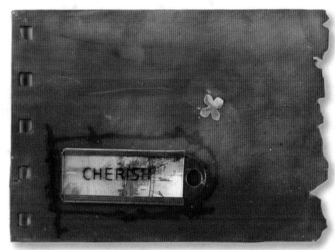

CHERISH

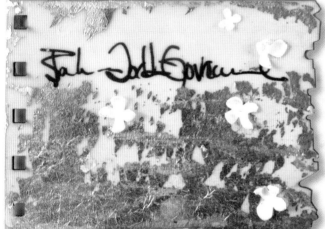

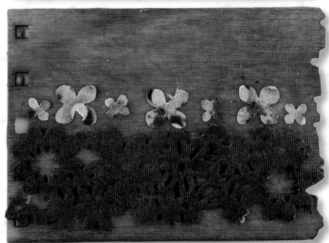

A GOOD BOOK

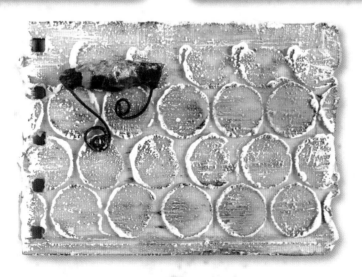

punchinella

Warm the wood page with the heat gun.

Apply encaustic medium to the surface.

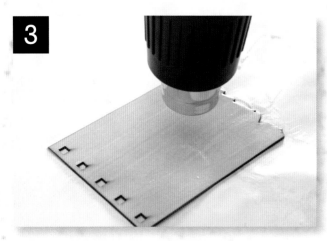
Fuse with the heat gun.

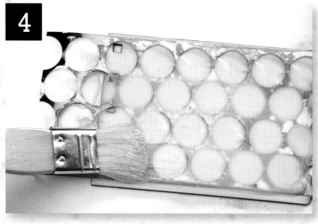
Place the Punchinella stencil over the page and apply a layer of wax.

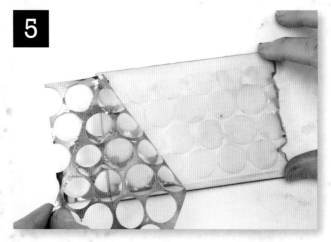
Remove the Punchinella stencil.

6

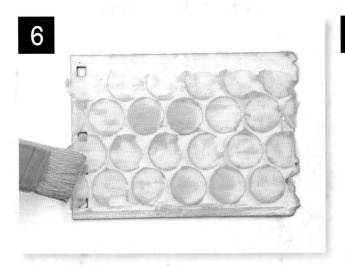

Dry brush the surface with Indian Yellow encaustic paint.

7

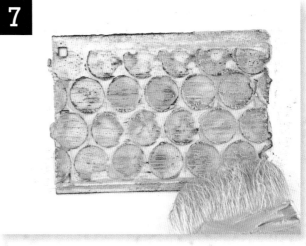

Dry brush more layers of encaustic paint over the surface (here, Quinacridone Magenta and King's Blue).

BRUSH UP

The dry-brush technique adds subtle texture to the wax. You want your brush to be only lightly loaded with medium, and the surface should be cool, not warm. Because heat would soften the wax and cause it to spread, you want the wax to be firmer to hold the shape and texture of the brushstrokes.

8

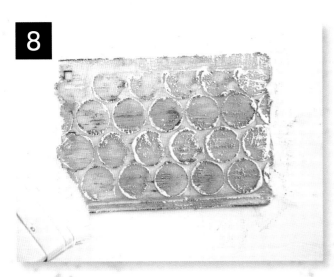

Apply a final layer of Titanium White encaustic paint in this same dry-brush technique.

9

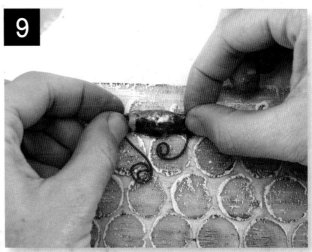

Press the wire and paper encaustic-dipped bead into the surface. If the surface is still warm enough from the dry brushing, it should adhere. Otherwise, fuse with the heat gun.

glue-paper burn

Warm the wood page with the heat gun. Apply encaustic medium to the surface. Fuse with the heat gun.

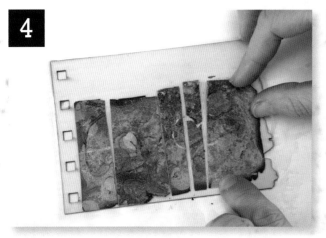

Arrange the burned-paper pieces on the pages, lightly pressing them into the wax.

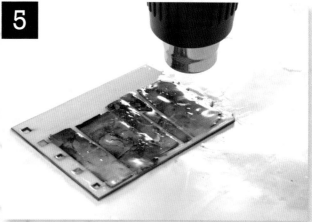

Apply medium to the board and then fuse with the heat gun.

Place a dab of medium on the back of the found-object embellishment.

Position the found-object embellishment on the burned-paper page and fuse the page with the heat gun.

rusted floral ribbon

1

Spray the page with ink. Allow it to dry.

2

Warm the inked page with a heat gun, and apply a layer of medium.

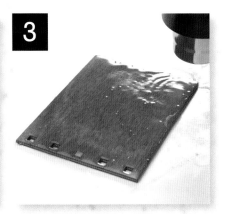

3

Fuse with the heat gun.

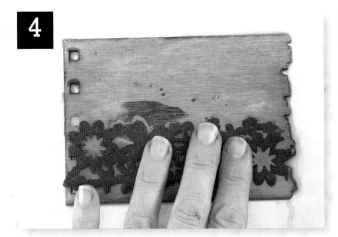

4

Place the rusted floral tape on the page, pressing lightly into the warm wax.

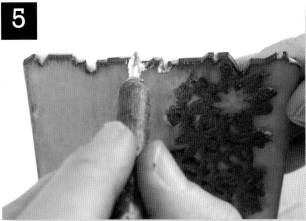

5

Use a stylus to remove excess wax from any parts of the page that you can't easily reach with a razor blade.

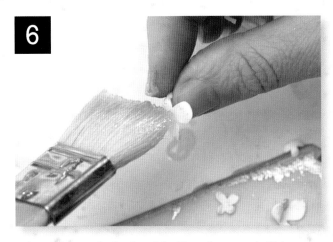

6

Dab medium to the backs of the Yupo flower embellishments.

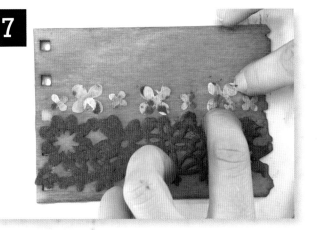

7

Press the flowers onto the surface of the blue-inked wooden page.

NOTE: If your wax layer is deep enough, you can just lightly press the die-cut embellishments into the warm surface and have them adhere, eliminating the need for step 6.

charm embellishment

1

Warm the wood page with the heat gun.

2

Apply encaustic medium to the surface.

3

Fuse with the heat gun.

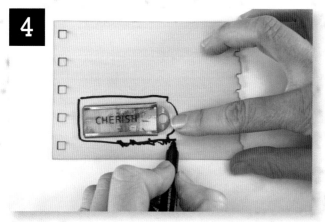

4

Position the charm where you want it permanently placed on the page and trace around it with a marker.

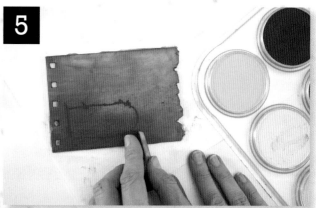

5

Apply PanPastels to the charm-embellishment page.

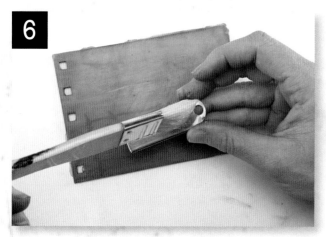

6

Apply medium to the back of the charm.

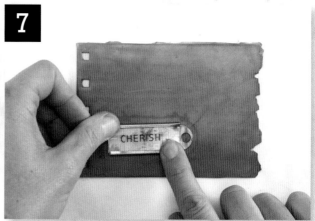

7

Place the charm in the outlined area and press lightly.

gold leaf

1

Warm the wood page with the heat gun.

2

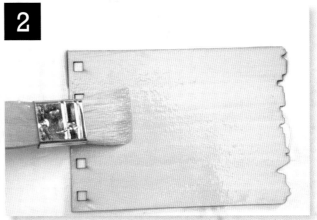

Apply encaustic medium to the surface.

3

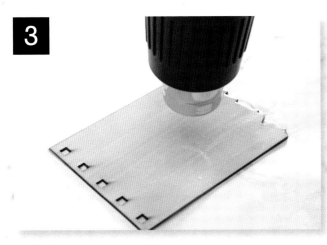

Fuse with the heat gun.

4

Write a design or message across the page using a marker.

5

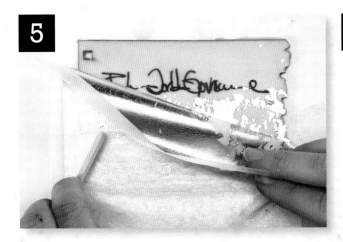

Place the gold leaf paper face down over the handwritten wood page. Use a craft stick to burnish the leaf onto the page. I like the sketchy application shown here.

6

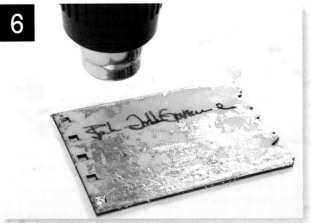

Fuse the gold leaf into the wax using the heat gun.

The embellishments in this section and used throughout the book are just a smattering of the play and experimentation I've been partaking in over the past months. These embellishments represent the best of my successes as well as my very favorite products.

The Yupo paper has been a studio go-to favorite for decades. My first 1st-place award was for a watermedia painting on Yupo. As you can imagine, such a win solidified my love for this surface! Distressing Yupo was the logical next step as I moved years and techniques beyond water media.

I discovered that the beautiful felt floral ribbon reacted beautifully to rusting thanks to input from Random Arts. What a treat to pull this into encaustic and see how nicely they work together!

And although I embrace these homemade embellishments far and beyond store-bought, I never pass up an opportunity to check out the latest ditties from the craft, art and hardware stores. I just fail to leave them as found. Decorative papers becoming torn strips, heavily glued to an almost unrecognizable form in delightful beads; rigid wrap is glued and burned, just the way I like! It becomes something new and innovative, so conducive to waxy mixed media.

So I continue to browse the store aisles and invest in inspiration: mixed media made completely new, unique through distressing, altering and enhancing in encaustic. Could there be a better path to trod?

Indulge yourself in these embellishment suggestions and see how joining them together with encaustic can be, as Henry Ford states in the quote below, truly a huge success.

> **"Coming together is a beginning.**
> **Keeping together is progress.**
> **Working together is success."**
> HENRY FORD

Duly Noted

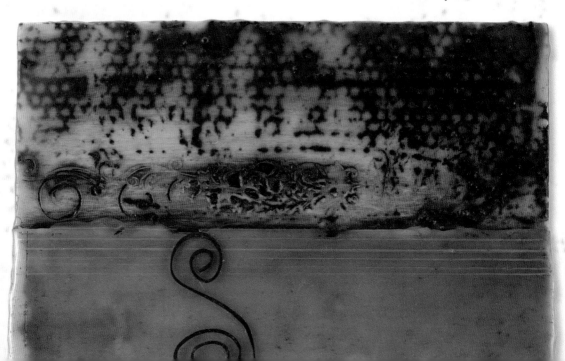

DEMO: RUSTED EMBELLISHMENTS

The idea of using rusted found objects as well as rusting interesting materials and partnering them with encaustic has turned out to be a very delicious, intriguing adventure. Here I've demonstrated with Random Arts felted floral tape, but the same technique can be applied to nearly any material that crosses your path!

WHAT YOU'LL NEED
Foam brush or sponge applicator
Iron paint (Modern Masters)
Felt floral ribbon or Wholey Paper (as desired)
Rust activator (Modern Masters)

Brush or sponge the iron paint onto the surface of your choice and allow it to dry. Here I'm using felt floral ribbon.

Dab the rust activator onto the painted surface with a foam brush or sponge applicator. Allow it to dry. Now your embellishment is ready to use in projects.

DEMO: RIGID WRAP EMBELLISHMENTS

Rigid wrap, otherwise recognized as cast material from your doctor's office, is a fantastic material for encaustic foundations as well as embellishments. I enjoy slumping the rigid wrap over forms to mold and cast it, but even more, I enjoy pushing the boundaries to see just how well it can support other encaustic experimentation.

WHAT YOU'LL NEED
Rigid wrap
Water
Metal forms
Cooking spray

Cut pieces of rigid wrap to the desired size and dip them in water.

Spray the forms with cooking spray so they won't stick. Drape the rigid wrap pieces over the forms and allow them to dry. Pop the rigid wrap off the form and use it in your encaustic.

DEMO: DIE-CUT EMBELLISHMENTS

I admit to not being the biggest fan of punch-and-place objects, but this machine won me over when I realized I could not only die-cut, but emboss as well. And not just with paper, but also with cork, wood veneers and fabric.

Place the die-cutting template, with your paper over the top, on the press.

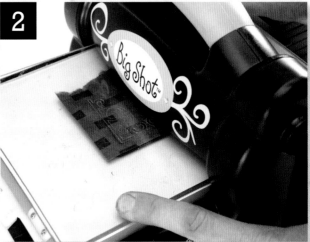

Place the glass plate over the top. Run it all through the Sizzix. Remove the die-cut elements from the press.

WHAT YOU'LL NEED

Decorative paper

Sizzix die-cutting machine

Die-cut templates

Reposition the paper and repeat steps 1 and 2 until you have the desired number of die-cut elements.

DEMO: EMBOSSED PAPER EMBELLISHMENTS

What else can you do with this Sizzix machine? You can make your own beautiful embossed papers. The embellishment I created in this mini demo is featured in the Wood Glue project on page 28.

WHAT YOU'LL NEED
- Decorative wood paper
- Sizzix die-cutting machine
- Embossing plates

Place the wood paper on the template.

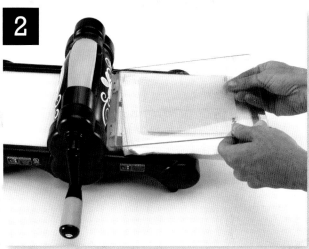

Place the template between the glass plates.

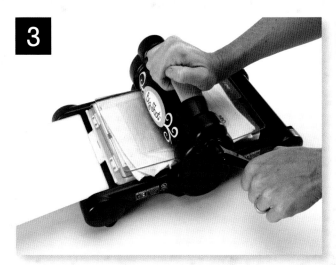

Run everything through the Sizzix machine.

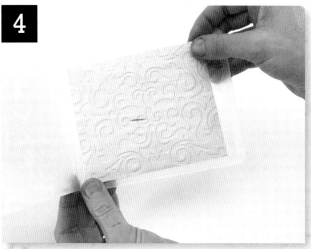

Release the paper from the template.

DEMO: GLUE-AND-PAPER BURNED EMBELLISHMENTS

I had a student direct me to this technique, suggesting it looks like leather when done on brown paper bags. I have yet to feel I've achieved such results, but I enjoy it so much I've tried it on just about every paper-like surface I could find. Feel free to experiment and see where it takes you.

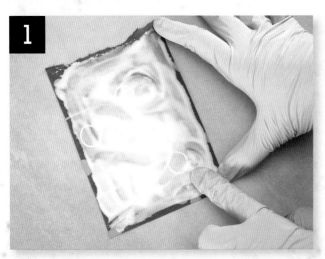

Apply a thick layer of glue on the surface of the decorative paper and smear evenly over the entire surface.

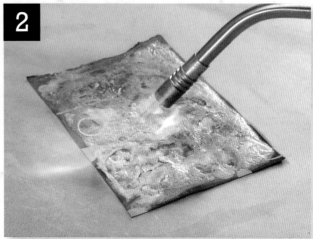

Put the glue-covered paper on a fire-retardant surface and run the torch over the surface. You can stop early for a light golden burn, or continue to burn and blacken in parts; it's all about your creative choice.

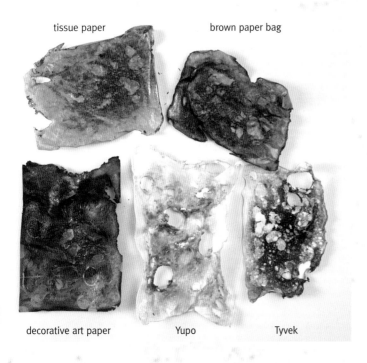

tissue paper brown paper bag

decorative art paper Yupo Tyvek

WHAT YOU'LL NEED

Wood glue or white glue

Various pieces of paper or plastic, such as tissue, brown bag, decorative, Tyvek or Yupo

Fire-retardant surface

Propane or butane torch

DEMO: YUPO EMBELLISHMENTS

I have been a big fan of Yupo since my early days in water media and I have a sizable supply stashed in a corner of my studio. I love having rediscovered it here and put it to task in the world of encaustic.

NOTE: Once "shrunk," these embellishments can be rusted as per the rusting demo on page 105.

WHAT YOU'LL NEED
- StazOn ink pads
- Rubber stamp (Stamping Bella)
- Yupo paper
- Scissors
- Single hole punch
- Stylus
- Heat gun

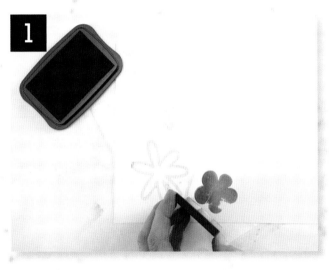

Ink up the rubber stamp and stamp onto the Yupo paper.

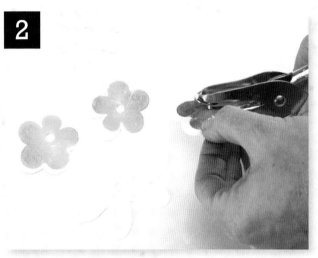

Roughly cut around the edges of the stamped flowers—no need to be exacting or particular. Using a hole punch, punch out the center of each flower where the stamen would be.

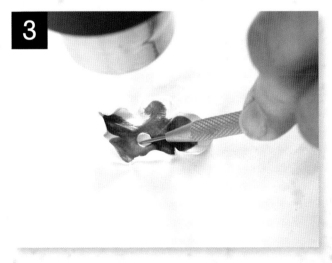

Place the tip of the stylus near the center of the flower to keep the flower from blowing away. Use the heat gun to shrink the flowers. Treat the gun almost like a styling tool, moving it around the flower so the petals curl up individually as they shrink.

BRUSH UP

I've found that StazOn works really well on wax and other slippery surfaces, like Yupo, without wanting to roll up, shrink off or otherwise misbehave.

If you are cutting out flowers, I've found that longer petals work best. The smaller flowers can shrink to mere blobs.

DEMO: RESIN EMBELLISHMENTS

No, resin and encaustic are not the best of friends. But they can be made to play well together. Here is the most basic technique for creating interesting bobbles and doodads for inclusion in your encaustic works of art.

WHAT YOU'LL NEED

Dark annealed steel wire

Wire cutters

Needle-nose pliers and/or jeweler's pliers

Resin, such as EnviroTex Lite Pour-On High Gloss Finish

Disposable cup

Craft stick

Patterned (or plain) tissue paper

Beads, buttons, glitter, microbeads

Paintbrush

Scissors or razor blade

Create a shape out of wire. Make sure your shape includes a closed space that can hold the resin.

Pour equal parts of the resin ingredients into a disposable cup and stir with a craft stick.

Tear tissue paper to fit the wire shapes and place it over the top of the shapes. Dribble the resin over the tissue paper.

Add glitter, beads and buttons as desired to the wet resin. Use a paintbrush to position the elements if necessary, and then set the piece aside to dry.

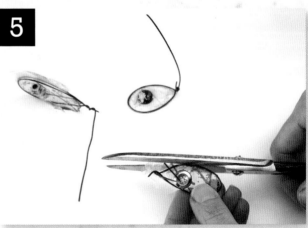

When the resin shapes have dried, trim the excess resin away from the edges with scissors or a razor blade.

DEMO: PANTY HOSE AND GLUE EMBELLISHMENTS

Many materials can be used to acquire the look of gut, or skin. The embellishment of these in mixed-media work—and especially in jewelry and wire sculpture—has become very popular. I love the look of this material and employ it with ease into my encaustics.

WHAT YOU'LL NEED

Dark annealed steel wire

Wire cutters

Needle-nose pliers and/or jeweler's pliers

Cut-up pieces of panty hose

White glue

Clothespin (optional)

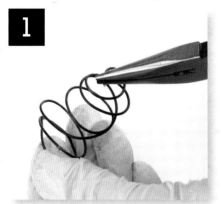

Create the wire form by twisting the wire into a spiral shape with pliers.

Tuck the wire form into the panty hose piece and wrap the hose around the shape.

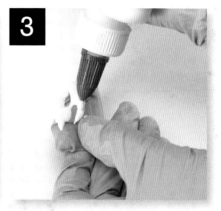

Apply a layer of the glue to the entire structure.

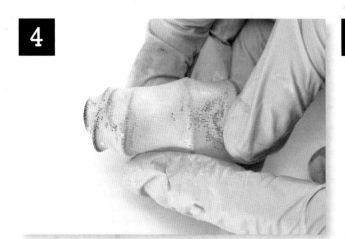

Smear the glue, tucking the excess panty hose material into the wire form. After the first coat is applied, set the structure aside to dry.

NOTE: If the panty hose unfurls when you set the piece aside to dry, secure it to the wire form with a clothespin. You shouldn't have to use the clothespin on subsequent layers.

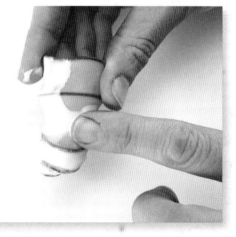

Apply as many layers of glue to the piece as you'd like. (This is the third layer of glue in this photo.)

NOTE: Wood glue will give the final piece a yellowish, antiquated look, and it works just as well as white glue. Keep that in mind if it will suit the look you wish to achieve.

DEMO: WIRE AND PAPER ENCAUSTIC-DIPPED BEADS

These simple creations add a delightful punch to many encaustic paintings and other dimensional works. Let your imagination run wild in choosing wire, papers and placement.

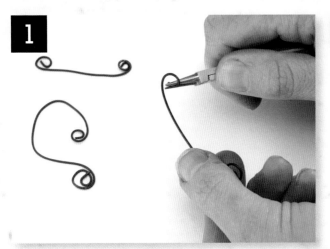

Cut as many lengths of the wire as desired. Use needle-nose or jeweler's pliers to twist the ends of the wire into loops.

Rip or cut strips of paper to fit the width of the wire base. You can make these strips as long as you like; longer strips will make thicker beads. Wrap the paper around the wire.

NOTE: For this purpose, you can use any kind of paper. Light-weight decorative paper will yield the best results because it's easiest to roll around the wire. It's also unlikely to have a mind of its own and unwrap when dipped in the wax. I also love the look of newspaper for this project.

WHAT YOU'LL NEED

Dark annealed steel wire

Wire cutters

Needle-nose pliers and/or jeweler's pliers

Decorative papers

Colored wire or thread (optional)

Encaustic medium

Heat gun

Metallic microbeads

Metallic powder

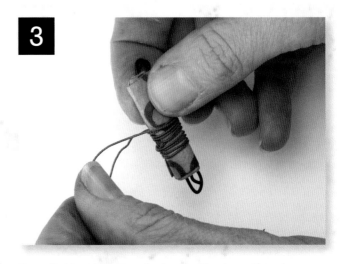

If you like, you can wrap the bead with wire or thread.

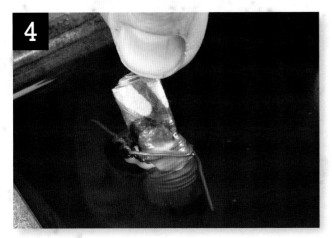

4

Dip the bead into the medium.

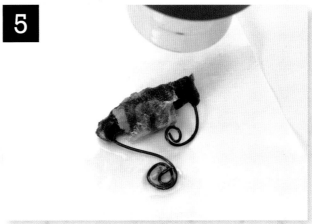

5

Use a heat gun to remove some of the wax from the bead if you feel the wax layer is too thick or if you would like to melt the wax away from the curlicue ends of the wire.

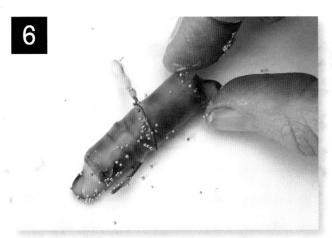

6

While the wax on the bead is still warm, roll the bead in the metallic microbeads, pressing them into the wax as needed to ensure that they adhere.

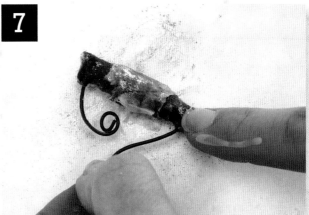

7

Sprinkle some metallic powder on your work surface and roll the still-warm bead through the powder.

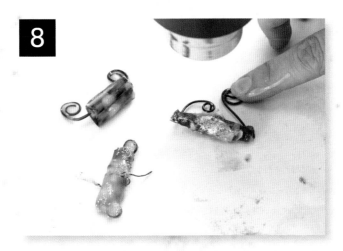

8

Heat the bead with the heat gun to further adhere the metallic microbeads and/or metallic powder as needed.

gallery

The encaustic pieces on the following pages exemplify just a few more of the many ways you can combine, showcase and repurpose the techniques and materials you've discovered within this book. I hope they inspire you to take your work in new and exciting creative directions.

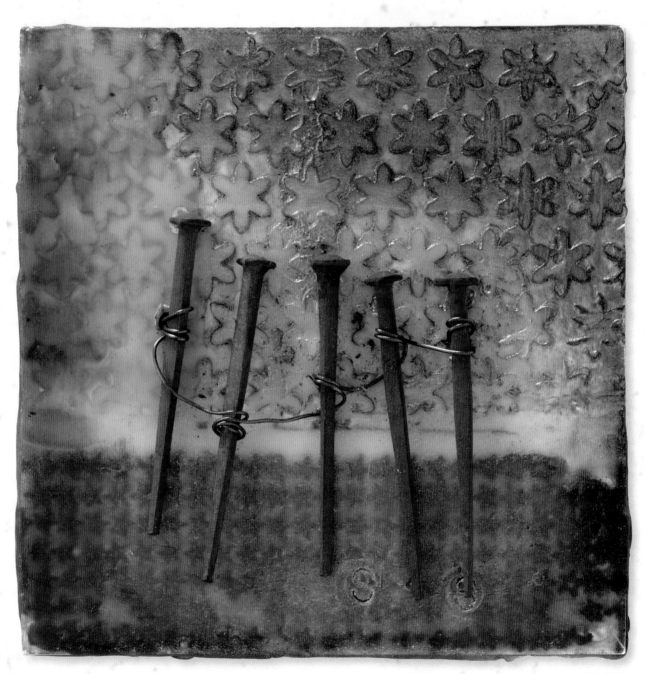

SEA GATE

UNTIL THE LAST

SWEETPEAS

FIRST GARDEN

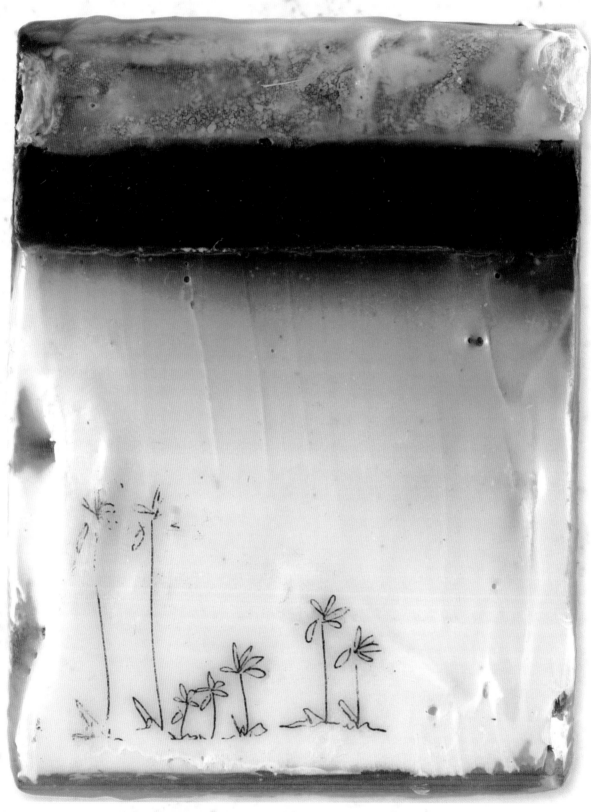

DRAWN ON PLASTER

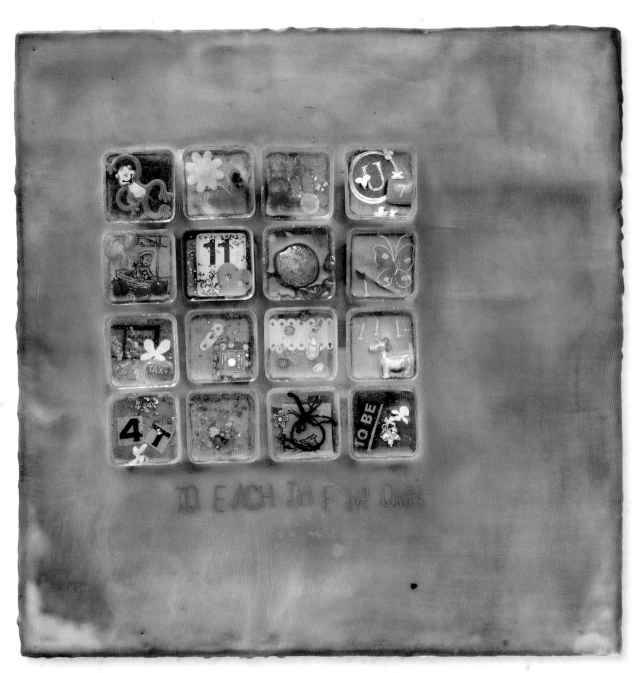

TO EACH THEIR OWN

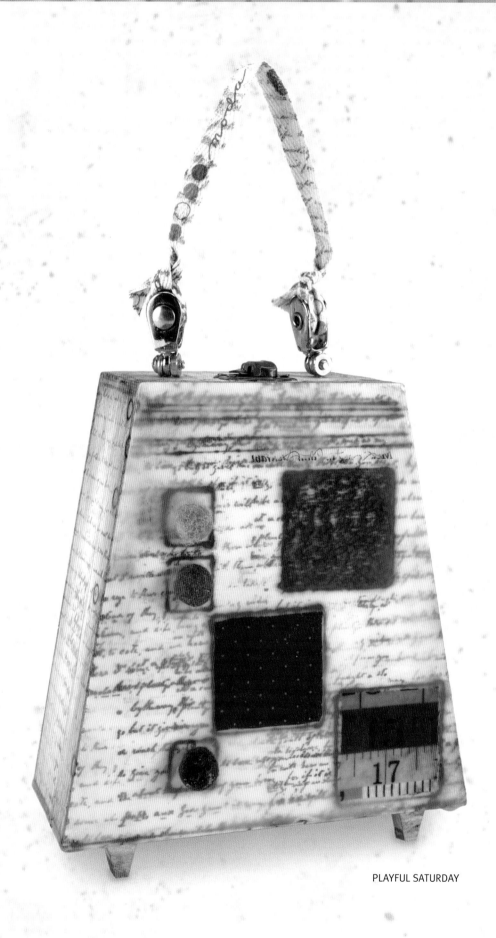

PLAYFUL SATURDAY

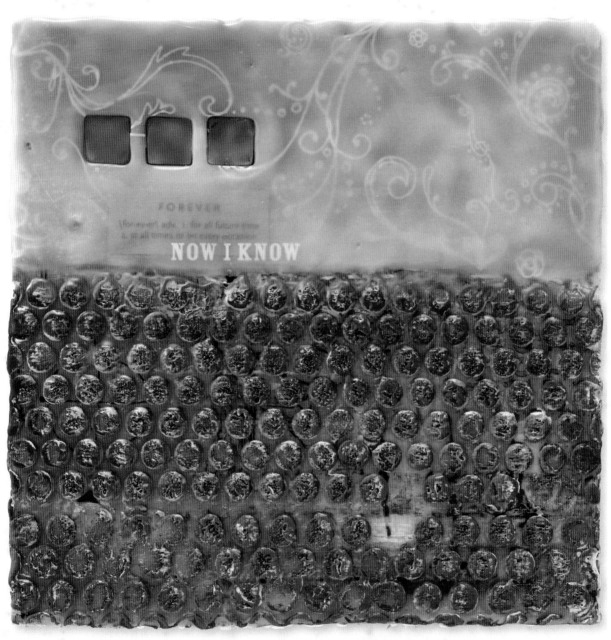

NOW I KNOW

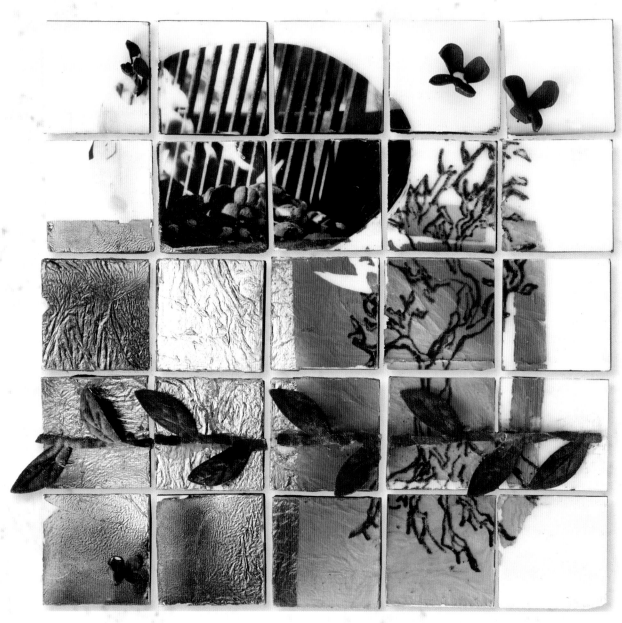

YUPO DIMENSION 1" ATC SQUARES

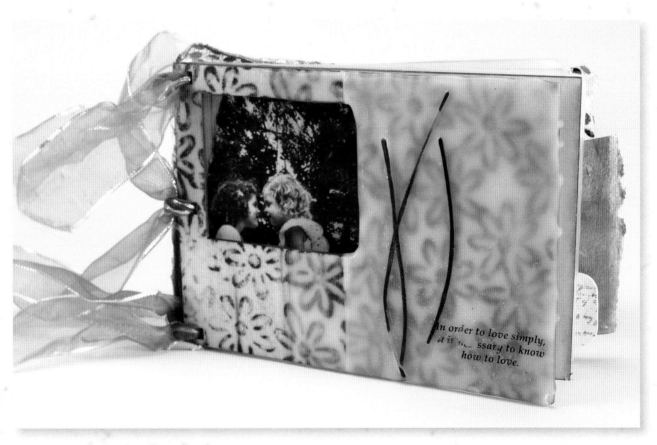

In order to love simply,
it is necessary to know
how to love.

SISTER COLLECTION

LITTLE BITTY

resources

Most of the materials used in this book can be found at your local craft, art or hardware store. The following are also wonderful resources.

Ampersand Art Supply
(800) 822-1939
www.ampersandart.com
Encausticbord, claybord

Colorfin LLC
www.PanPastel.com
PanPastels, trays and tools

Colwood
(732) 938-5556
www.woodburning.com
Wood-burning tools and tips

Daniel Smith Artists' Materials
www.danielsmith.com
Pigments, tins, brushes, R&F paints

Encaustikits
www.encaustikits.com
Packaged project kits

Environmental Technology Inc.
(707) 443-9323
www.eti-usa.com
Resin

Evans Encaustics
(707) 996-5840
www.evansencaustics.com
Paints and supplies

Gauche Alchemy
gauchealchemy.wordpress.com
Punchinella, ephemera

GOLDEN Artist Colors
(800) 959-6543
www.goldenpaints.com
Gels, pastes, fluids, gessos

Grafix
(800) 447-2349
www.grafixarts.com
Rub-Onz Transfer Film

Graphic Products Corporation
(800) 323-1660
www.gpcpapers.com
Decorative papers, embossed papers, flocked papers

Judy's Stone House Designs
(970) 622-9717
www.judysstonehousedesigns.com
Wood book forms, purse forms, acrylic pendants, wood pendants

NW Encaustic
www.nwencaustic.com
Paints and supplies

R&F Handmade Paints
(800) 206-8088
www.rfpaints.com
Encaustic medium, encaustic paints, pigment sticks, palettes, heat guns

Sizzix
(877) 355-4766
Sizzix.com
Die-cutting, embossing machine and accessories

Speedball Art Products
www.speedballart.com
Gold leaf, Simple Leaf, pigment pots

Stamping Bella
(866) 645-2355
www.stampingbella.com
Stamps, ink pads, acrylic beads and buttons, spray ink

Stencil Girl Products
Stencilgirlproducts.blogspot.com
Stencils and wood icing

Wagner Encaustic
www.wagnerencaustics.com
Paints, mediums

ADDITIONAL RESOURCES AND INSPIRATION

Art Unraveled
www.artunraveled.com
Workshops

Artfest
www.artfest.com
Directory of events

Encaustic Art Institute
www.eainm.com
Workshops and gallery

Encausticamp
(360) 239-8081
www.encausticamp.com
Retreats and workshops

Interntional Encaustic Artists
www.intrnational-encaustic-artists.com
Workshops and seminars

Sitka Center for Art and Ecology
(541) 994-5485
www.sitkacenter.org
Retreats and workshops

The Artists' Nook
(970) 416-1148
www.theartistsnook.net
Mixed-media workshops

The Encaustic Center
www.theencausticcenter.com
Workshops and gallery

The Upstart Crow
(604) 940-1155
www.theupstartcrow.ca
Workshops and seminars

about the author

I do not profess to be excellent; far from it. But then, what is the definition? Is excellence a once-and-done goal to be reached, or is it something we strive toward in each and every moment of our lives? Over and over again, seeking to be excellent in this awakening, excellent in this hello, excellent in this next encounter, excellent in this next task.

So in this definition, I am excellent because I repeatedly strive to make excellence a habit of my day.

And today I give to you a bit of this excellence. Today I give to you the piece of me that strove to be the best encaustic artist and author for this book, *Encaustic Mixed Media*. Today I give to you the excellence of my habit to prove the versatility and malleability of beeswax to be above all else.

I will have moved to a new place by the time you pick up this book and read my words. I will have moved into a new habit of excellence and begun to work toward a new level of experimentation or encouragement or excellence. I will look to the words and works of this book, in its most excellent form at release, and see the change that has occurred since then; surely being much too discriminating and determining it not at all the excellence I'd thought on this day of writing!

But that is the beauty—or the bane—of excellence. If one is to truly be so, to strive for this habit in character and performance, one has to be prepared to look back from a newly achieved level of excellence and accept the place that was called excellent the day or week or year before.

So it is with humble pride, tremendous gratitude and weary release that I give you *Encaustic Mixed Media*. Putting all of my current heart, soul and effort into making it all that it can be; the excellence that is its potential and knowing that there will be a new level to share with you as I grow in my habit to be and become most excellent.

IN LOVE,

Trish

Trish

"We are what we repeatedly
do. Excellence, therefore, is
not an act but a habit."
ARISTOTLE

Trish (aka Patricia) is first and foremost the blessed wife of a compassionate and gracious man, the proud mom of four beautiful redheaded young men and one precious young woman, and the follower of one awesome and magnificent God. When not investing her time and talents in discovering her unique path in this life, Trish travels throughout the world teaching encaustic painting and has recently been called to start a business to bring encaustic to a broader, more far-reaching audience through Encaustikits and Encausticamp. She is most passionate about the connection and inspiration that happens each time she is gifted the opportunity to cross paths with eager participants. Look for her online at www.gingerfetish.blogspot.com, www.encaustikits.com and www.encausticamp.com.

index

More Ways to **Explore** Your Art

www.CreateMixedMedia.com

The online community for mixed-media artists

TECHNIQUES • PROJECTS • E-BOOKS • ARTIST PROFILES • BOOK REVIEWS

For inspiration delivered to your inbox and artists' giveaways, sign up for our free e-mail newsletter.

ENCAUSTIC WORKSHOP

Patricia Baldwin Seggebruch

In *Encaustic Workshop*, you'll be introduced to encaustic painting. Techniques include adding pigments to color the wax, layering in texture, adding foils and photos and more. Complete projects show you how to combine techniques to create more complex finished pieces and a gallery offers additional inspiration.

MIXED-MEDIA PAINT BOX

Edited by Tonia Davenport

Open up your paint box and delve into a year of creative ideas from 45 of your favorite artists. Each week, you'll be guided with step-by-step instructions through a different project or technique that will add instant depth and drama to your art.

FLAVOR FOR MIXED MEDIA

Mary Beth Shaw

Whether you love experimenting with flavors or following a recipe to a T, *Flavor for Mixed Media* will be your guide to creating your most delectable works of art ever. Mary Beth Shaw shares her mixed-media techniques for incorporating textures, creating multiple layers, developing a distinct flavor and more.

Interested in encaustic workshops, supplies and inspiration?
Visit author Patricia Baldwin Seggebruh websites at www.encausticamp.blogspot.com, www.encaustikits.blogspot.com and www.gingerfetish.blogspot.com.

These and other fine North Light Books titles are available from your local craft retailer, bookstore, online supplier, or visit our website at www.ShopMixedMedia.com.